ROBERT WHITE

Discovering
Old Cameras

SO-AGF-567

SHIRE PUBLICATIONS LTD

Contents

ACKNOWLEDGEMENTS

I am most grateful to many of the curators of museums listed in this book for providing information about their collections. My warm thanks go to Harry Shaw, Gary Tysoe and John Wade for allowing me to photograph cameras from their collections. Figures 1, 2, 3, 6, 7, 8, 10, 12 and 13 were drawn by James Fenton and published by the Historical Group of the Royal Photographic Society in a series of 'Camera Cards'. My thanks go to James Fenton and Arthur T. Gill, Chairman of the Historical Group, for permission to use them. I especially thank John Wade, editor of *Photography* magazine, for his continued encouragement and for reading and correcting the typescript.

Cover photograph, top left to bottom right: Instantograph, 1896; Folding Pocket Kodak, 1905; Kodak Brownie, 1930; Ensign Tropical Roll Film Reflex, 1927.

Set in 9 on 9 point English roman by Permanent Typesetting & Printing Co. Ltd., Hong Kong, and printed in Great Britain by C. I. Thomas & Sons (Haverfordwest) Ltd, Press Buildings, Merlins Bridge, Haverfordwest.

1. Introduction

This book is about cameras from the first hundred years of photography—from its announcement in 1839 to the precision miniature cameras which made the German industry pre-eminent in the years leading up to the war in 1939.

The invention of photography is a fascinating subject but little can be told here; a full account can be found in the books listed in chapter 9.

In 1839 the first photographic process was announced to the world. The daguerreotype, invented by Louis Daguerre, a Frenchman, was a direct positive on a silvered copper plate. The silver surface was polished, fumed with iodine vapour to make it light-sensitive and, after exposure, subjected to mercury vapour. This produced a white deposit corresponding to the highlights of the subject, against more or less unchanged polished silver. When viewed, the daguerreotype was turned until the remaining shiny silver areas reflected a dark background, against which the highlights clearly stood out.

An Englishman, William Henry Fox Talbot, demonstrated an alternative method of making photographs in 1839. His Photogenic Drawing process used paper coated with silver chloride. But it produced a negative image: light parts of the subject were rendered dark on the paper. However, a positive was easily made by passing light through the negative on to a second piece of sensitised paper pressed into contact with it.

Only the daguerreotype, which was patented, was used commercially to any extent. It required only a few minutes exposure in bright sunlight, a time which was reduced to less than a minute as improvements followed in the years after its discovery. Photogenic Drawing paper had to be left in the camera until the image appeared. This took hours rather than minutes. By 1841 Fox Talbot was able to announce an improvement, the calotype, which still used the paper negative process. Exposure times were reduced to minutes when he found that an invisible 'latent' image was formed on the paper which could be revealed by chemical treatment with a developing agent. It enjoyed limited success.

The cameras used for both pioneering processes were based on the earlier camera obscura used by artists. A lens was placed at one end of a wooden box; at the other went a holder carrying the metal daguerreotype plate or sensitised paper. With a simple rigid box, focus was fixed or, at best, was limited to sliding the lens a little in an outer sleeve. By telescoping one box inside another the focusing range was greatly extended. This was called a sliding box camera; it became the typical daguerreotypist's tool.

Lens improvements figure prominently in camera evolution. The first to be designed specifically for photography, rather than borrowed from one end of a telescope, was worked out by Professor Petzval and made by Voigtlander in 1841. It gave a sharp, well defined image only in the middle of the picture but this was fine for portraiture. With its very high speed it did much to make commercial portraiture possible in the early days of the daguerreotype.

Paper negatives, however carefully prepared, or rendered translucent by waxing, could not give really fine detail. Glass was tried, but it was only in 1851 that a satisfactory way was found of bonding light-sensitive chemicals to it. Frederick Scott Archer discovered it, but he did not patent it and later died in poverty. He used collodion, a solution of guncotton in ether. The plate was coated with a mixture of collodion and potassium iodide in solution. When nearly dry it was immersed, in the dark, in a silver nitrate solution. After a minute or two to allow the formation of silver iodide on its surface, the plate was withdrawn, drained and put into a plateholder whilst still wet. The picture had to be taken and the plate developed before the surface dried or it was ruined. This was called the wet collodion or wet plate process.

The negative captured wonderfully fine detail which gave crisp prints. Alternatively the black image could be bleached white. When a plate treated in this way was placed in contact with a black background it became a direct positive, rather like a daguerreotype but without its brilliant surface. These positive collodions were called ambrotypes in the USA, a term which has now spread to Britain.

In compensation for the tricky manipulations, the wet collodion process could be used by amateurs or professionals without the hefty fee demanded for operating a licence under the daguerreotype patent. This freedom, and the low price of glass compared with the daguerreotype plate, soon saw portrait studios doing a roaring trade. Customers could buy a single ambrotype, often presented in a small leather-covered case, like a daguerreotype, or a small paper print, mounted on stiff card. These little prints were called cartes de visite, or CdV for short. The name came from France, the country in which they first became popular. The street or beach became the studio for the while-you-wait photographer who made collodion positive portraits on blackened tinplate. Correctly called ferrotypes, the popular name for these photographs was tintype. Processing took place on the spot, either inside the camera or in little light-tight containers dangling from it. A minute or two was all that was needed to send the customer away with a still damp and rather drab likeness.

Other professionals toured the land photographing famous

buildings, landscapes, statues and tombs. Paper prints of these sold in large numbers; especially popular were stereoscopic pictures, mounted side by side on stiff card ready to be seen in three dimensions in the viewer or stereoscope. Amateurs soon grew in numbers, particularly amongst the better off who had both time and money, for photography was still expensive as a hobby.

All this activity created a demand for cameras—many more than were needed previously. The simple wooden fixed or sliding box-form cameras worked just as well for wet collodion plates as for calotype paper or daguerreotypes. Indeed, for pictures out of doors they even formed their own carrying case for the chemicals needed to prepare and process the plates. But designers have always tried to make cameras lighter and smaller, as they still do today. To ease the burden, one of the earliest methods was to use the basic box form but to make the ends removable. After they had been detached, the central section, which was hinged at the corners, could be folded quite flat. The sliding box camera came in for the same treatment so that each half also folded flat.

Clearly that was a cumbersome way of making a camera occupy less space. During the 1850s and 1860s a number of folding camera designs appeared in which lens board and camera back were joined by a detachable cloth bag or, more successfully, by permanently attached pleated bellows. Initially for outdoor work and increasingly in the studio, bellows cameras replaced the rigid and sliding box forms.

A craze for stereoscopic photography resulted from public acclaim and royal patronage for examples shown at the Great Exhibition of 1851. To recreate an illusion of depth, two photographs were taken of the same object with the camera moved a few inches along a track between the first and second shot. A more convenient arrangement, especially for portraits or other subjects where movement might occur between exposures, was the binocular camera. As its name suggests it had two lenses, mounted side by side, so that both pictures could be taken at the same time. The sliding box pattern was used for both single lens and binocular types; bellows versions were usually binocular.

Thousands of cheap stereoscopic viewers were sold in the 1850s and 1860s, and millions of stereoscopic views. They were the equivalent of today's picture postcard, travel magazine and Sunday colour supplement rolled into one. Most of the stereoscopic pictures of the period, frequently on yellow board mounts, were taken and sold professionally. The number taken by amateurs was relatively small.

Black fingers, stained by silver nitrate, were the hallmark of the wet-plate photographer. It was possible to use specially prepared dry collodion plates but, as they were so much slower than wet

ones, they were suitable only for landscape and still-life subjects. Quite a number of stereoscopic cameras were equipped with six or a dozen dry collodion plateholders. For wet plates it was usual only to supply one. Some later bellows cameras of the collodion period were fitted with one wet and one dry plateholder.

In the middle to late 1870s a succession of experimenters perfected plates which, when used dry, were as fast as wet ones, and indeed faster. The magic combination was silver bromide supported in a layer of gelatin. By 1878 it was possible to buy ready-prepared dry plates and chemical manipulations were reduced to the comparatively simple tasks of developing and printing. Amateur photography mushroomed. More people had leisure time and money than ever before. Travel by bus, tram, train and bicycle had spread and people wanted to go further afield—and bring back pictures of their trips. Demand for cameras grew rapidly. Cabinet makers turned photographic equipment makers, for cameras were still made from mahogany and brass, traditional materials of the cabinet trade. Cameras were made with changing boxes or magazines to hold a dozen dry plates which could safely be loaded weeks before exposure.

From the 1880s to the turn of the century a wide variety of cameras was sold which could be hand-held if the light was good enough. At first they were greeted by the older hands with considerable suspicion, even derision, and with some justification. With a traditional camera, the ground glass screen allowed the photographer to get his subject pin-sharp and properly composed. With a firm camera stand there was no problem of camera shake. The user of a hand camera had to judge distances by eye and set them on a focusing scale. Although satisfactory for distant shots it was not so easy for closer pictures, which were often blurred. The shortest exposure possible with early dry plates was around one twenty-fifth of a second, with the lens at its widest aperture. It called for an exceptionally steady hand to match the results from a stand camera. Nevertheless the hand camera soon had its devotees, who could take pictures in the market place or on the beach without small boys clustering round as they did when a tripod was set up. Taking pictures of your friends without their knowing or of pretty girls at the seaside was a great novelty. Indeed cameras were sold disguised as brown paper parcels, books and hats, and some were hidden behind cravats and waistcoats. But these detective cameras, as they were called, sold only in tiny quantities. However, it was not long before *any* hand camera, hidden or not, was sold as a detective camera. To avoid confusion, it is usual today to describe the true detective cameras as disguised cameras.

Normal hand cameras were made as rigid boxes, scaled-down versions of traditional bellows plate cameras, and both single

and twin lens reflexes. Hand cameras got a spur in the early 1890s when much faster lenses were designed and made following the introduction of new optical glasses in Germany. Called anastigmat lenses, they were capable of excellent definition at apertures around f6.8 and soon f4.5, which was very fast for the time.

Plate cameras had a drawback. When the supply in one's plateholders or magazine was used up, a darkroom was needed in which to change them for fresh ones. Many chemists' shops had tiny darkrooms for the purpose, for they were the photographic dealers of the day. Use of the room was free—provided one bought a box of plates first! The dry plate worker had to do his own developing and printing as well as loading plates. In 1888 an American, George Eastman, saw a golden opportunity. He arranged for the manufacture of a simple box camera which was sold ready loaded with a long roll of paper-based film sufficient for one hundred round pictures, each 2½ inches (64mm) in diameter. After the pictures were taken the camera was returned to Eastman's factory, where the film was processed and the camera, reloaded with fresh film, was sent back with a bundle of prints. Eastman solved two problems at once: the need for darkroom loading of the camera and the previous necessity for the photographer to do his own developing and printing. The camera brought a new name to photography: it was the Kodak.

Eastman later went on to bring into widespread use celluloid film with a paper backing.

By this time, 1895, local developing and printing services were more widely available, particularly from chemists' shops. So, by 1900, to the already large band of amateur photographers who carried out their own processing was added an ever increasing number of snapshooters who were happy to pay someone else to do the work. The demand for cameras was enormous. Wood was no longer used exclusively for camera bodies. Aluminium and its alloys, by the late 1890s, were cheap enough to be used for some camera metalwork with a noticeable saving in weight. The workshop industry, which was responsible for all the earlier cameras, continued to make hand-crafted, high-quality and special-purpose equipment, but the cheaper apparatus for amateurs and snapshooters was increasingly made in factories with mass production of parts.

Before 1900 even the cheapest camera cost the best part of a week's wages for a working man. Photography was for the better off. But then George Eastman, with a sure hand for a business venture, put a simple but effective roll-film box camera on the market for 5 shillings, about a quarter of the price of any other camera. It had a name which was to become synonymous with snapshot photography for the next sixty years, the Brownie camera. The name came from the characters in a children's story

book then popular in North America. Kodak introduced a range
of well made folding roll-film cameras at about the same time.

Today a range of cameras from one manufacturer would all use
the same negative format and differ only in the degree of
automation and lens quality. In the 1900s it was quite the
opposite. Cameras may well have been fitted with much the same
quality of lens and shutter; the difference lay in the negative size.
Even in 1900 to 1920 enlarging was a slow and cumbersome
business. Electric light was not available everywhere. Most
negatives were contact printed on to gaslight or printing-out
paper. If you wanted, and could afford, big postcard-size
photographs you had to use a large postcard-size negative
camera, such as a 3A Folding Pocket Kodak. If you could not
afford that, there was the very popular Number 1 Folding Pocket
Kodak giving a picture 2¼ by 3¼ inches (57 by 83mm). By 1916
there were nine sizes of picture taken by Kodak cameras ranging
from 1⅝ by 2½ inches (41 by 64mm) to 4¼ by 6½ inches (108
by 165mm).

Although roll-film photography was expanding rapidly, there
was just as great an increase in picture taking on glass plates.
Considering that plates were heavy and easily broken and had to
be loaded into holders in a darkroom, it seems surprising that roll
films did not replace them very quickly. But plates kept very
much better than early roll films and they were rather more
reliable. However, the continued popularity of plates lay in value
for money—they cost only a third of the price of roll films.

So, in the period leading up to the First World War, plate and
roll-film cameras developed alongside each other. Roll-film box
cameras had their counterpart in magazine plate cameras. These,
too, were box-shaped but held six or a dozen plates within the
camera which were released, one at a time, after exposure to a
storage chamber. Folding roll-film cameras came to look
increasingly like folding plate cameras. The only real difference
was the longer back of the roll-film models to accommodate the
spool holders. Reflex cameras used plates almost exclusively. The
bulky twin-lens pattern gave way to the quickly improving single-
lens reflex, which, by 1914, was well liked by both serious
amateur and professional photographers.

There have always been photographers who prefer small
cameras, ideally ones which can be tucked away in a pocket. They
were well catered for in Edwardian times with diminutive cameras
taking 45 by 60 mm (1¾ by 2⅜ inch) plates and very small roll-
film models such as the Ensignette and Vest Pocket Kodak.

A war-weary world took a few years to get industry going again
for domestic items like cameras for the amateur. Some companies
survived the war, others amalgamated, and the rest disappeared.
Apart from the big companies, Houghton and Butcher who

amalgamated, most British concerns were quite small and concentrated on making high-class traditional cameras.

German cameras had a reputation for quality and good handling from before the war. From the early 1920s they were back in business in the home and export markets with well made plate and roll-film models with good lenses and shutters. In 1925 a German precision instrument company, which had not sold cameras before, marketed one which had been designed using skills normally reserved for such things as microscopes. Using 35mm film, it produced the then tiny negatives of only 1 inch (24mm) by 1½ inches (36mm). Every picture on the roll had to be enlarged, for contact prints were too small. It was launched with such an apparent disadvantage, and at a time of economic difficulty, that a poor future was forecast for it. It took five years or so for its popularity to grow until it became one of the most respected camera names of all time. It was the Leica, a name coined from the company *Leitz* and *ca*mera. It paved the way for precision all-metal cameras such as the Rolleiflex, a 2¼ inch (60mm) square roll-film twin-lens reflex launched in 1928, and the great range of 35mm cameras made by Zeiss Ikon—the Contax, Super Nettel, Contaflex and Tenax, all of which appeared in the 1930s.

In 1933 another highly innovative camera came along which married precision camera construction to the single-lens reflex principle. The Exakta was a small camera taking eight pictures, 2½ by 1⅝ inches (64 by 41 mm), on 127 roll film. Refinements soon came: a range of shutter speeds from 12 seconds to one thousandth of a second, wide-angle and telephoto lenses, built-in flash synchronisation (one of the first cameras to have it) and close-up and microscope adaptors. It led to all today's single-lens reflex cameras; indeed a 35mm version, the Kine Exakta, appeared in 1936, with a similar specification to its larger roll-film brother, but with the added advantage of bayonet-mounted lenses.

Following the lead of the highly successful Rolleiflex, the 2¼ inch (60mm) square twin-lens reflex became one of the most influential cameras of the 1930s. It was a favourite of professional and advanced amateur photographers who enjoyed making large, high-quality enlargements.

Folding roll-film cameras were also extensively developed in the 1930s. Several interesting models were sold with coupled range-finders, including such cameras as the Prominent and Rangefinder Bessa by Voigtlander and Zeiss Ikon's Super Ikonta.

The only British company of any size, Ensign Ltd, as Houghton Butcher had become, attempted to compete only in the folding roll-film market with their Selfix and Autorange cameras. They did not make a twin-lens reflex or 35mm camera at all.

The 1930s also saw a vogue for very small cameras, taking tiny pictures on unperforated 9.5mm and 16mm cine film. Some, like the cheap moulded plastic Midget, by Coronet, were little better than toys. Others were serious attempts at what were later to be called sub-miniature cameras. The Minifex was like a scaled-down 35mm camera, which was rather dominated by its Compur shutter, even though it was the smallest size made. Quite the opposite was true of a camera made in Latvia, using unperforated 9.5mm film, giving a negative a mere 8mm by 11mm. From the outset the design philosophy was to create a camera that was as small as practicable and yet give negatives of sufficient quality to yield acceptable postcard-sized enlargements. The body, lens, shutter, viewfinder and film holder were all original designs; nothing was borrowed from existing cameras. The result in 1937 was the Minox. It is made today in Germany and the latest version looks much like the original, a fitting tribute to the innovative skills of its creator.

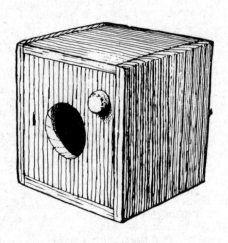

Fig. 1. One of Fox Talbot's mousetrap cameras.

2. The early period 1840-80

The inventors of the first photographic processes spent most of their energies in solving chemical problems: first, making a sheet of material sensitive to light and, having done that, killing the sensitivity to prevent the image from vanishing as it was viewed! It was perfectly natural that they should use cameras which were already available for their experiments. It sounds odd to say that cameras existed before photography was invented, but they did. For centuries artists had used lenses to throw an image on to a sheet of paper or a ground glass screen so that the outline could be traced to give a reasonable record of the scene. Sometimes a whole room was used—a camera obscura, or dark room. More conveniently a camera obscura was a portable box with a lens at one end and a piece of ground glass at the other. To make the task easier, a mirror was sometimes placed at an angle within the box to reflect the view on to a horizontal sheet of ground glass.

It was William Henry Fox Talbot's failure to make a good sketch with the camera obscura and another drawing aid, the camera lucida, which led him to use his well trained scientific mind in solving the problem of letting nature record itself on paper which had been chemically treated to react to light and shade. He failed with his efforts using his portable camera obscura and tried, in its place, some very small home-made cameras which were simple cubical wooden boxes. His wife, Constance, called them mousetraps. He used lenses from microscopes, reasoning that the small cameras, with relatively large lenses, would speed the process compared with his camera obscura. He was right. The Science Museum in London has the oldest negative in the world, taken in 1835 of a lattice window at his home, Lacock Abbey, Wiltshire. The building is now in the care of the National Trust. You can still see the window at Lacock and also visit an excellent museum devoted to the originator of the negative/positive process. For later experiments, he had a number of cameras made professionally to his own designs. With these later cameras, detachable holders were used for the paper, replacing the earlier method of pinning or sticking it to the inside of the back of the camera.

A separate holder was also used in the first camera to be sold commercially, the Daguerreotype, made by one of Daguerre's relatives, Alphonse Giroux. It was a large camera taking a daguerreotype plate approximately 8½ by 6½ inches (216 by 165mm). This soon became known as whole plate— a term which survives today for sheet film and paper sizes. The body was made from two pine boxes, one of which slid inside the other, telescope fashion, but designed with a lightproof join between them.

Focusing from landscapes to portraits was easily achieved by sliding the smaller box in or out. The lens was specially made for the camera to the best design available at the time, an achromatic meniscus invented around 1812.

One of the problems with primitive lenses and early processes was akin to colour blindness. Daguerreotype plates and calotype paper were sensitive only to the blue end of the spectrum. But the human eye tends to favour the red end when focusing an image on a ground glass screen. Since the wavelengths differ, blue and red rays do not come into focus at quite the same distance of the lens to the screen. Early photographers soon found they had to make a slight adjustment to the lens, after focusing, to get sharp results with their blue-sensitive materials. A man called Cundell designed a camera with a scale to indicate the precise readjustment needed. It was the first camera with a focusing scale. Later lens designs brought red and blue rays into focus at the point which did away with the problem.

Achromatic meniscus lenses were very slow, but they were not designed for photographic use. To make the new invention profitable, something was needed to speed the process sufficiently to make portraiture possible. Fuming the plate with bromine after an initial dose of iodine vapour gave a very much faster daguerreotype plate and this helped enormously. The other main contribution was a lens working at a relatively large aperture of around f3.6. Based on calculations by Max Petzval, it was the first lens designed for photography. It gave only a narrow angle of sharpness but that was ideal for portraiture. At first, in 1841, it was made by the well established optical company Voigtlander, who fitted it to an all-metal camera. It was shaped rather like a cannon. A brass cone, with a shallow taper, carried the lens; a squatter cone, to the rear, held the plate.

A different approach was used by an American, Alexander Wolcott, in 1840. He hurried along the exposure by using a concave mirror to form the image. Apart from its speed, it gave an image the right way round; daguerreotypes taken with lenses were reversed from left to right. The mirror was placed at one end of a wooden box facing the plate. Light passed through the open front of the box and was reflected by the mirror on to the plate. It was certainly fast, but a mirror 7 inches (178mm) in diameter gave images only about 2 by 2½ inches (51 by 64mm), which was quite small. A Wolcott camera was used by the first man to take up a daguerreotype licence in England, Richard Beard. He operated his studio in London from 1841; a replica of it has been set up as the centrepiece of the Science Museum's photographic gallery. If you are lucky, you may come across one of Beard's daguerreotypes. His name was stamped into the gilt surround which separated the plate from its cover glass.

It would be wrong to give the impression that tapering metal tubes or reflecting mirror instruments were typical of daguerreotype and calotype cameras. The most common form, by far, was the humble rigid or sliding box. With a fixed box the focusing range was limited to the amount by which the lens could travel in its mount. This was seldom sufficient for both landscapes and close-up portraits. Additional focusing range was achieved by putting two or more slots in the camera top to take the plateholder. Hinged covers kept light out of the unused slots.

The focusing range provided by the sliding box camera was sufficient for anything from landscapes to close-up pictures. The smaller box, which was usually at the back of the camera, was moved by hand and locked in position by a turnscrew. A variation, used by a number of makers from 1860 to 1880, put the smaller box at the front and controlled its motion by fitting a rack and pinion for fine focusing.

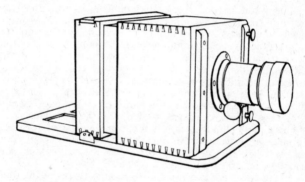

Fig. 2. A sliding box camera.

Calotype photography required little extra equipment beyond the camera; a plateholder, a camera stand and a few dishes were enough. It was rather different with daguerreotypes. The plate had to be held in a firm support, polished using powders and a buff, fumed in light-tight boxes over iodine and bromine and, after exposure, be put back into another wooden box for developing over a pan of mercury. Not many complete outfits have survived intact but they can be seen at the Science Museum, the Kodak Museum and the Royal Photographic Society's National Centre of Photography at Bath.

After 1851, when the wet collodion process was announced, it was soon taken up, displacing both the daguerreotype and paper

negative processes. It, too, needed a lot of extra equipment since the plates had to be prepared just before use and be developed before the surface dried. Photographing out of doors required taking your darkroom with you. This would be folding and tent-like and often it fitted inside a wooden box like a suitcase and was set up on a tripod. With it went chemicals for sensitising, developing and fixing the plates. Large darktents were built into handcarts and more than one itinerant photographer converted a horse-drawn carriage into a mobile darkroom to go from town to town. Several people, including the inventor of the process, Frederick Scott Archer, devised oversized cameras which allowed the chemical manipulations to be carried out within them.

The tidiest arrangement was the Dubroni camera from France. Inside the small cubical body was a roughly spherical glass or earthenware vessel. This had three holes in it: one each at the front and back for the lens and plate, and another light-trapped one at the top. An iodised collodion plate was put into the back of the camera and pressed into watertight contact with the rear aperture of the vessel by springs in the hinged back door. Silver nitrate solution was then fed into the vessel through the top hole by a glass tube. When the solution was safely in the bottom of the vessel, the camera was tilted to wash it over the surface of the plate, making it sensitive to light. Any excess was sucked back. After exposure, the developer and fixer followed the same route. To see how development was coming along, the camera lens was held to the eye and a special door opened in the back of the camera. This revealed a sheet of red glass against which the developing plate could be seen without any danger of fogging. Dubroni cameras were sold in small boxes fitted with blank glass plates and all the necessary chemicals and apparatus for developing and printing.

Most cameras were expensive in relation to wages in the mid nineteenth century. In 1854 a box camera, with two slots for taking landscapes and portraits on plates up to 7 by 6 inches (178 by 152mm), cost £10 10s complete with chemicals, paper and ancillary apparatus for calotypes. The price was the same for a set similarly equipped for wet plate photography. Some early cameras have lost their plateholders; this is a pity, because they help to tell us which process was used. For wet collodion work, the plateholders were very solid; they had a groove at the base to catch the drips and a silver wire across each corner on which the plate rested. Inside they were blackened and stained by silver nitrate. Calotype holders were shallower and free of staining and held two sheets of glass between which the paper was sandwiched.

A professional photographer, working out of doors, could carry his chemicals inside his sliding box camera. But camera makers, ever inventive, set out to make their cameras as portable

as possible. Both single and sliding box cameras were made in patterns which were designed to fold flat. First, the front and back panels were detached leaving the hollow open-ended box in the middle. This was hinged at the corners and down the centres of the side panels. With a couple of taps, the sides concertinaed inwards until the box folded flat. They were called folding box and folding sliding box cameras. They were less robust than the rigid versions and few have survived in good condition.

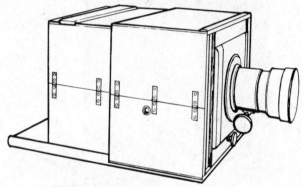

Fig. 3. A folding sliding box camera.

Another way of making a camera lighter and more compact when folded was to use a flexible light-tight covering to connect the lens board to the plateholder. The most common method used a pleated flexible leather 'box' known as bellows. One of the earliest bellows cameras produced in any numbers was a daguerreotype camera made by Lewis in the USA. It first sold in 1851. But the Lewis camera was rather like a sliding box camera with the centre section joined by bellows. These increased its focusing range but did nothing to increase its portability.

Some British designers were looking for ways of making large cameras fold for carrying in faraway places. Captain Fowkes designed one which used a cloth bag covering; Ottewill made teak versions of it to a government order for use in Britain's widespread empire. Bag coverings, however, were soon displaced by the more convenient bellows.

A camera style which was to prove very popular was the square bellows field camera. It was also called a tail board or folding tail camera from the way it folded for storage. The baseboard was hinged about a quarter of its length from the lens board. After use, the bellows were pushed up to the front of the camera and

the baseboard folded up behind them. This also protected the vulnerable ground glass screen. During the taking of photographs, the baseboard was held in position by a variety of means. The 'shutter bottom' camera had a sliding wooden panel in the base which bridged the fixed and hinged sections. Brass stays were very popular and Meagher and Hare both favoured hinged wooden side panels often called wings.

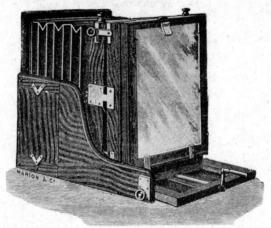

Fig. 4. A tail board camera with wing support.

A still more compact camera, using paper negatives, was designed by C. G. H. Kinnear in 1856 to take on a photographic tour of France. The bellows were fixed to the back of the camera and detachable from the front. With the bellows removed, the lens board folded flat to the camera base. The whole camera formed a neat box for carrying. The special advantage of Kinnear's design was bellows which tapered towards the lens. When compressed, each fold nestled inside the next larger one so that they took up the smallest possible space. Many Kinnear pattern cameras were sold over the next thirty years or so, especially by Rouch, Meagher and Ottewill.

Although mahogany was the most frequently used wood, teak was favoured for equipment destined for use in the tropics. It was supposed to be more resistant to warping in the heat and humidity and to ward off attack by insects. As a further safeguard, extra brass plates were added at the more vulnerable spots such as corner joints. Brass-bound teak equipment is amongst the most handsome of all old photographic apparatus.

Most lenses up to the middle 1860s were achromatic meniscus, Petzval portrait and one or two early combination designs. To improve sharpness and depth of field, stops were used in front of the lens. These were discs or caps of brass, with a central hole or aperture, which were placed over the front of the lens and held in place by a sliding cylinder of brass. In 1858 a Mr Waterhouse suggested cutting a slot in the lens mount to take a strip of brass in which the aperture had been cut. Supplied in sets of graded diaphragm size, Waterhouse stops rapidly became the method of choice for controlling lens aperture. A big improvement in sharpness and flatness of field came with a new type of lens in 1866. It was issued in Britain as the Rapid Rectilinear and in Germany as the Aplanat. With a maximum aperture of f8 and a reasonably low price, it was popular until well into the twentieth century.

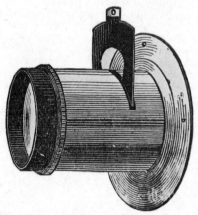

Fig. 5. Lens with Waterhouse stop.

While the pioneers were at work trying to invent a photographic process, Professor Wheatstone turned his attention to another optical phenomenon—stereoscopic vision. He reasoned that if two drawings, showing an object from slightly different viewpoints, were presented in a device which allowed each eye to see only one of the views, the images would coalesce in the brain to give an impression of a single object, but in relief. He proved the point by making some simple line drawings which were viewed in an apparatus of lenses and mirrors called a stereoscope. At the time it was an intriguing scientific curiosity which advanced no further. The invention of photography brought it to life again.

Pairs of photographs, made with the camera moved a few inches sideways between exposures, when viewed in the stereoscope gave an illusion of depth just as the eyes had originally seen it. David Brewster, in 1849, came up with a much simpler viewer. It was just a tapering box, with the pair of pictures at the wide end and two lenses at the other. A central divider allowed each eye to see only one picture. When stereoscopic daguerreotypes were shown in such a stereoscope at the Great Exhibition of 1851 they created so much interest that a huge public demand grew for viewers and pictures. Millions of cards were printed of every subject under the sun.

A stereoscopic pair could be taken with a sliding box camera which was moved a few inches sideways between exposures. However, it was important to keep the camera level and pointing at the subject or the pictures would not fuse easily in the stereoscope. A baseboard with wooden struts providing a parallelogram movement was one convenient way of repositioning the camera between exposures. Another form of single-lens stereo camera used a track along which the camera was moved after the first exposure. Separation of several inches, even a foot or more, exaggerated the stereoscopic effect and was used to give added depth to landscapes.

By the mid 1850s cameras were sold with two lenses side by side to take the stereo pair simultaneously. These binocular cameras, as they were called, were easier to use though they were rather more expensive than the single-lens variety.

Single-lens cameras, by and large, were made before bellows became popular but the binocular form is found in both box and bellows patterns.

The popularity of stereoscopic pictures waned after the 1860s; from the multitude of cards sold perhaps there was little left to photograph!

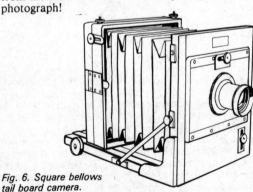

Fig. 6. Square bellows tail board camera.

3. Plate cameras after 1880

Dry plates were used before 1880 but were so slow that they were restricted to landscape, architectural and still-life scenes. Starting in the early 1870s, a succession of experimenters, working from a suggestion that silver bromide, suspended in a gelatin base, might give a better dry plate, had by 1878 achieved a speed comparable to wet collodion. Mawson and Swan of Newcastle upon Tyne and the Britannia Works Company Limited of Ilford started commercial production in that year. Early dry plates were poured by hand, often from teapots, but in 1880 George Eastman, in America, designed a machine to do the job. From the Britannia Works grew Ilford Limited and George Eastman became Eastman Kodak in the USA and Kodak Limited in the UK.

It took a year or two before some experienced photographers, brought up on wet plate work, came to accept that the dry process gave results which were as good, if not better. But, in the end, they joined the ranks of the enthusiasts for the new and much more convenient method. At first, little change was seen in the cameras. However, before very long they were made just for dry plate use, not only for professional photographers but for the many amateurs who were attracted to the hobby by the ease with which photographs could be taken. Dry plate cameras, or just plate cameras for short, have had a long history. They are still being made today, though glass plates have now given way to cut film. Plenty of different models and types were made in the sixty years between 1880 and 1940. With such variety it is easiest to look at them in three groups: stand cameras, used only on a tripod, and often called field cameras; hand or stand cameras, for use in the hand or on a tripod; hand plate cameras, primarily for hand-held exposures.

Stand cameras

At first, stand cameras were no more than simple developments of the square bellows, tail board and taper bellows Kinnear camera styles. Indeed, the tail board continued virtually unchanged until well into the twentieth century and was preferred by professional photographers who wanted a rock-steady camera for close-up and technical work. As wet plate cameras, they were usually supplied with only one plateholder; more were of little use when the plate had to be made, used and developed without a break. Dry plate cameras usually came with holders for several plates, say six or a dozen. Nearly every manufacturer of wooden cameras made tail board models at some time. For amateur use, smaller, lighter folding tail cameras were made from the later 1880s. The International by J. Lancaster and Son and the

Instanto by E. and T. Underwood are perfect examples.

It was the taper bellows style which became most popular in the end. A lighter, slimmer camera was bound to be favoured when it had to be carried around all day with a tripod and several holders all loaded with glass plates. From the basic Kinnear camera several styles evolved. All had four common parts: a baseboard with an inner, sliding panel for focusing; a front panel carrying the lens; a frame at the back to hold the ground glass screen and darkslides; and bellows to join the front and back together. But there were so many variations in the way the parts were put together that it is not possible to describe them all. For simplicity we shall look at them under two main groups.

1. *Folding baseboard*. The baseboard was usually solid or had a small hole in it through which the lens projected when the camera was folded. The frame carrying the ground glass screen was permanently fixed to the base, but the lens panel support, which ran in channels or rails in the baseboard, could be set at any position along its length.

2. *Open frame baseboard*. The base was usually an open frame or had a large circular opening bounded by a brass ring into which clipped separate tripod legs. In contrast to the folding baseboard type it was the front which was fixed; the rear frame was free to move in tracks up and down the baseboard until held by turnscrews.

Both types had their particular advantages. When folded, the baseboard of the first completely enclosed and protected the lens and bellows. However, the second allowed more scope for camera movements such as extreme rising front and back and front swings.

George Hare was the first to adopt the folding baseboard pattern in 1882. It was widely copied: Rayment's Patent Camera of just a few years later was very similar. A U-shaped mahogany support, carrying the lens panel, travelled in grooved tracks in the focusing bed. It could be secured at any point along its length by tightening knobs on brass rods which ran through the mahogany uprights to the bed. A knob at the side of the baseboard moved the inner panel, or bed, for focusing by means of a rack and pinion. Plenty of rising front was possible with these cameras but few had provision for front swing movements. However, back swing was frequently provided by altering the angle between the back and the baseboard or by attaching a separate frame to the back of the camera by four slotted brass strips. The solid baseboard usually had one or two threaded bushes to take a tripod screw. Diameters and pitch were not standardised until the 1900s,

and this caused problems if the wrong tripod screw was taken out on a day's photographic outing.

Very often the back of the camera was completely square, thus allowing the frame holding the focusing screen or plateholder to be detached and repositioned through 90 degrees. In this way both upright and landscape views could be taken with the camera base firmly fixed to the tripod—a much steadier and more convenient arrangement than unscrewing the camera and reattaching it on its side.

In the simplest cameras, the ground glass screen was completely removed when it was time to fit the plateholder. But it was very fragile and all too easily trodden on if it was set down on the ground near the tripod. So, in many field cameras, the screen was attached to the back by a double-action hinge which allowed it to be swung out of harm's way over the top of the camera. Lancaster had a useful parallelogram arrangement which held the screen an inch or so from the back of the camera, leaving room to slide in the plateholder. American manufacturers favoured the spring back, in which the screen was free to move backwards but was held firm against the camera by a couple of long flat springs. The plateholder was forced gently into the gap between screen and camera; spring tension held them both in place.

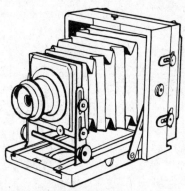

Fig. 7. Lancaster Instantograph camera.

Rayment's Patent Camera, beautifully made by Perken, Son and Rayment, cost £7 5s in the half-plate size in 1890. That included a tripod, but a lens cost extra. Probably the most popular camera of this type, although the baseboard was pierced by a hole to take the lens, was Lancaster's Instantograph. They were sold in tens of thousands; a half-plate outfit, including lens, cost only £4 4s in 1890. The price dropped to £3 10s by 1900!

The drop baseboard style of field camera lent itself very well to further development, as we shall see later, but we now turn to the second type of taper bellows field camera. The chief variations were in the way the lens panels were attached to the base. In some, they were permanently held by hinges; in others they were detached before the camera was folded. One favourite fixing method was a brass strip, with keyhole slots in it, screwed to the front of the focusing bed, which engaged in screwheads projecting beneath the lens panel. In a more elegant version, brass rods at the bottom corners of the panel dropped into slots in the bed and were kept in position by sliding catches. With the hinged front, only the outer U-shaped support was attached to the base. The central lens panel, attached to the bellows, was free to pivot. When collapsing the camera, the U-support folded backwards, the inner panel rotated in the opposite direction and both ended up flat against the bottom of the camera. The feature, which was well liked, combined strength with light weight. By 1900 it had been adopted by most manufacturers. Watson's Acme, Ross's Century, Thornton Pickard's Ruby, College and Imperial and Houghton's Victo and Sanderson were all popular. For a half-plate outfit comprising camera, lens, tripod and three plate-holders, prices ranged from £4 10s for the Victo to around £11 10s for the Ruby, Century and Acme. The Acme was one of relatively few cameras offered with aluminium rather than brass fittings. In 1900 this cost an extra £2 10s.

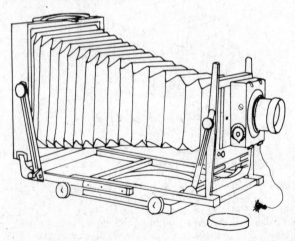

Fig. 8. The Victo: a taper bellows field camera.

They shared with the folding baseboard cameras the square back with removable frame for horizontal and vertical pictures, hinged ground glass screens and facilities for back swing. By running a long slot through the centre of the supporting strut, the hinged front lens panel could be locked at an angle to the base to give a substantial amount of swinging front. A Mr Sanderson of Cambridge patented a double, slotted strut system which was even more versatile. Houghton made Sanderson field cameras from 1895 until the Second World War—they were regarded by many as unbeatable for architectural photography.

Since the base of these cameras was often an open frame, a tripod could not easily be attached by the usual screw and bush. Instead a brass ring, some inches in diameter, was set in a circular brass surround. The ring, which was free to rotate until locked by a clamp, had three equally spaced lugs to which the tripod legs were fitted.

The bellows on most field cameras were long enough to stretch to twice the focal length of the lens, a feature known as double extension. When they were fully extended, life-size pictures were seen on the plate. Some cameras had a second focusing track, which moved backwards, in addition to the usual forward moving one. This gave triple extension for larger than life shots.

Hand or stand cameras

The larger folding baseboard camera pioneered by Hare and Rayment, when reduced to the proportions of a quarter-plate or 5 by 4 inch (127 by 102 mm) model, served as an excellent basis for hand-held cameras. In the early 1890s American manufacturers such as the Blair Camera Company, the Boston Camera Manufacturing Company and Eastman Kodak were amongst the first in the field. They were largely responsible for covering the wooden bodies of hand-held folding plate cameras with leather. British and European makers soon followed their lead.

Pictures with a hand-held camera needed short exposures; a built-in shutter was essential. Some early pattern shutters, such as the roller blind, were used in Britain, but they looked ungainly on the neat cameras. An American optical company solved the problem in the early 1890s with a neat two-blade between-the-lens shutter. This was the Bausch and Lomb Optical Company and its most famous shutter was the Unicum, dating from 1897. Exposure time was controlled by the travel of a piston, within a cylinder, mounted just to the right of the lens. The greater the travel, the more time it took for the air to escape, and the longer the shutter stayed open. A matching cylinder to the left of the lens was connected, by rubber tube, to a large rubber bulb. A squeeze pushed the piston and tripped the shutter. This was the commonest way of setting off any shutter at the time; the B

setting on modern cameras goes right back to the days when a short time exposure was given by holding the shutter open for a second or two with a rubber bulb.

As well as a shutter, a hand-held camera had to have a focusing scale and viewfinder. The brilliant pattern finder was usually fitted. The view was seen, very much reduced, in a small square lens set above a mirror and second lens at right angles. The cameras could be used just as well on a tripod and a ground glass screen was always provided. This dual role led to their description as hand or stand cameras.

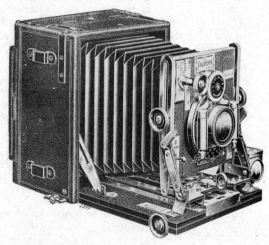

Fig. 9. A hand or stand Sanderson camera.

In the early years of the twentieth century the smaller, leather-covered folding plate camera developed in two ways. In the first, the cameras were substantially built, with long bellows extension, plenty of rising front and quite often front swing movements. They were for the professional or serious amateur photographer. Although used in the hand, they were at their best when mounted on a tripod. Most famous was the hand or stand Sanderson camera by Houghtons, which shared the double-slotted lens board supports of the field Sanderson described earlier. It was held in great esteem by a generation of photographers. Selling at a higher price, and in smaller numbers, was the beautifully made Una by J. Sinclair. In 1910 a quarter-plate Sanderson with an f6.8 Dagor lens cost £10 17s 6d and a Una £13 15s, with the same lens. Other makers of cameras of this type were

Lizars, Thornton Pickard, Adams, Dallmeyer and in Germany Carl Zeiss and Voigtlander. From these sophisticated early models came the technical cameras of later years whose descendants are the professional's tools of today such as the Linhof and MPP.

The other course followed by smaller folding plate cameras was towards lighter, even pocketable models, with restricted rising and cross front and no swing movements. Many were cheap, with the simplest lens and shutters. These were just snapshot cameras for family album pictures, the equivalent of a box camera which took plates—but plates were only a third of the price of roll film. As roll films became cheaper and better in the 1920s and 1930s, the simple models died away. However, the folding plate camera was also fitted with very fine lenses and shutters. They were very popular from the 1900s up to the 1930s; latterly they were frequently used with film packs or roll films in adaptors. Although at first both body and baseboard were made from wood, aluminium baseboards came into use around 1900 and a little later bodies too were made in light metal. This made them both smaller and lighter. German industry made these all-metal cameras very well; indeed, many cameras sold under British labels had been made, under contract, in Germany.

Popular cameras were the Klito, by Houghton, and Butcher's Cameo and Klimax. From Germany came the Voigtlander Bergheil, Vag and Avus, the Tenax by Goerz, Ernemann's Heag and, after the 1926 Zeiss Ikon merger, the Ideal, Maximar and Trona. In short, nearly all manufacturers listed hand-held folding plate cameras.

In a class by itself was the Sibyl, by the English company Newman and Guardia. Introduced in 1905, it had a lightweight drawn aluminium body and lazy tong strutting at each side of the bellows. Only the very best lenses were fitted, together with Newman and Guardia's accurate and almost silent pneumatically controlled shutter. It was expensive: in 1914 a quarter-plate New Ideal Sibyl with an f4.5 Tessar lens cost £19, complete with case and six plateholders.

The hand plate camera

Burton's *Modern Photography*, published in 1894, includes the following paragraphs in a chapter on 'The Selection of Apparatus':

'There is a natural tendency, at the present time, on account of advertisements of the "You pull the string, we do the rest" kind, for the beginner to take to hand camera work. Now I am going to say nothing against the hand camera, as I become daily more convinced of its usefulness, but I consider that hand-camera work is not for the

beginner...If a photographer intend to confine himself to plates no larger than 3¼ by 4¼, or at most 5 by 4, there is no harm in getting a hand camera of the many kinds that can be used as an ordinary camera on a tripod. At first it should of course be used in this way.

'As for those folks who go in for shooting with a hand camera at all and sundry, not even attempting any knowledge of photography, and then send the plates or films to be developed by a professional photographer, all I can say is nothing in this book is written for them.'

There were indeed plenty of people who were very content to shoot at all and sundry and let someone else do the processing. But Professor Burton's advice was no doubt quite sound for 1894, even if it was a little stuffy. In any event, the plate camera designed primarily to be used in the hand went from strength to strength. Naturally most hand plate cameras took rather smaller negatives than was usual at the time. Quarter plate was very popular. Although some were larger, there was no point in having a hand camera once you got much above 5 by 4 inches (127 by 102 mm).

Hand plate cameras settled down into three basic types: box form; bellows with side struts; and reflex. Reflex cameras are dealt with in chapter 5 so we shall look at the other two here, starting with box-form hand plate cameras.

Perhaps the novelty of being able to take 'instantaneous' pictures with a hand-held camera tempted people into disguising the equipment so that the photograph could be taken with the subject quite unaware. From the 1880s onwards cameras were secreted in hats, cravats and the tops of walking sticks, but these were rarities even then. It was far more usual to take a simple wooden box camera, cover it with brown paper or cloth and make a little hole for the lens to peep through. Soon manufacturers were offering such equipment as detective cameras—shades of Sherlock Holmes perhaps.

Novelties soon wear off, but the name stayed on and was regularly applied in the late 1880s and 1890s to hand-held cameras of any sort—disguised or not. Paper wrappings gave way to box-shaped rigid canvas or leather cases containing a camera, box or bellows type, and a few darkslides. The 'case' had cut-out portions for the lens and viewfinders, but this was now more for convenience than disguise. A popular model was Tylar's Tit-Bit camera. Sometimes a bag changer was used in place of the plateholders. This was a wooden box containing a dozen plates topped by a light-tight flexible leather bag. After an exposure, the front plate was felt through the bag, pulled up and tucked at the back of the stack. The next plate was then ready for exposure. Twelve plates took the space of six in holders. Eventually the

canvas or leather outer box was dispensed with and the wooden camera body was itself covered with leather. Most box-shaped cameras of this sort had simple lenses and shutters but some, such as Newman and Guardia's Special Pattern B and Adams's Yale, had anastigmat lenses and multispeed shutters.

Fig. 10. A magazine plate camera.

As an alternative to the separate bag changer, mechanical devices were built into box cameras to hold a dozen plates and change exposed for fresh ones on pushing a button or pulling a lever. In a darkroom, plates were slipped into individual tinplate sheaths and placed, in a stack, into a chamber in the back of the camera. When the plate-changing lever was operated, the first plate fell forward into a well in the base of the camera; the next moved forward into position for another picture. Magazine cameras, as they were called, were tremendously popular. However, they were reputed to have two serious faults. Tales were told of the first plate sticking, rather than falling, and so being exposed twelve times. The reverse also happened. If the release mechanism was faulty all twelve plates went into the well at the same time! However, these cameras were cheap and robust, and many have survived. Most were fitted with achromat or rapid rectilinear lenses, but a few had anastigmats. The blade shutters were usually capable of some speed variation, either with pneumatic control or a friction brake. Focus was either fixed or

27

altered by built-in supplementary lenses; the best cameras had a short length of bellows operated by rack and pinion.

Like so many Victorian and Edwardian cameras, the magazine box frequently bears the name of neither camera nor maker. Most were made by contract manufacturers in Britain and Europe, especially France and Germany, and sold by chemists' shops, chain stores, cooperatives and department stores under some fancy name of their own. Although a name appeared in the advertisement, it was not usually found on the camera. Happily some makers were proud enough to label their wares. Perhaps the best known are Houghton's Klito and Holborn cameras and Butcher's Midg. Magazine plate cameras were made from around 1890 until the First World War. In 1900 prices ranged from about £1 to £3 for a well made camera.

In the early 1890s R. and J. Beck brought out the Frena, a magazine box camera with a difference. Instead of glass plates it took twenty or forty sheets of stiff celluloid-based films in a special holder. After exposure, one quick twist of a handle released the sheet of film into a storage compartment in the back of the camera. In the darkroom it took only a moment to slip in twenty or forty sheets of film, just like a pack of cards, as the makers advertised.

French makers favoured the gently tapering box camera after the success of Jules Carpentier's Photo-Jumelle, or Binocular camera as it was called in Britain. With two lenses on the front, it is often mistaken for a stereo camera. It does not help when the importers, the London Stereoscopic Company, put their name on the camera. However, one lens belongs to the viewfinder. Its longish flat body did lend itself very well to stereoscopic pictures and many genuine stereo cameras were made with a similar body shape. The Jumelle pattern, as the cameras were known in Europe, was among the earliest of all hand-held models to be used with an eye-level viewfinder.

The last type of hand camera to be described is the bellows camera with side struts. The bellows were either conventional multipleated or had just two flat panels. In place of the drop baseboard, side struts were used to hold the lens panel and camera back firmly in position. J. Shew was one of the first in the field with his Eclipse in 1885. The slightly tapering side flaps were made of thin but very strong wood. One was hinged to each of the short sides of the body. The lens board was pulled forward, between the struts, until it located in grooves at their leading edge. It was a unique design, well liked at the time but not much copied. So skilfully were they manufactured that the struts took the strain without cracking or buckling. Most of the ones I have seen are still in excellent shape. Shew followed the Eclipse with a range of cameras of similar basic design but with a little more sophisti-

cation under the family name of Xit.

Ottomar Anschutz had been experimenting with focal plane shutters for high-speed photography in the 1880s and 1890s. Goerz made a rigid tapering box camera using the Anschutz shutter in 1890 and followed it with a folding version in 1895. The second camera was little more than a box containing the shutter attached by two-fold bellows to the lens board using a spring-loaded folding strut at each corner. Like the Jumelle, it could only be used with the eye-level viewfinder. The style was copied by a number of manufacturers and was particularly suited to lightweight, compact cameras. This property endeared it to press photographers. The Minimum Palmos, Nettel and VN were famous press cameras which followed the lead of the popular Goerz-Anschutz.

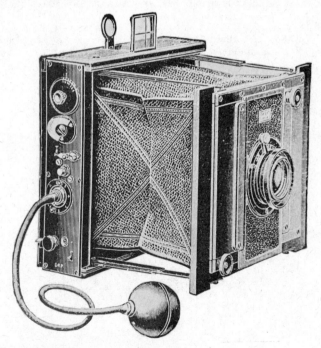

Fig. 11. A Goerz Anschutz camera.

4. Roll-film cameras

Ever since Fox Talbot showed that paper could be used as a base for negatives, people had the idea of using it in rolls in place of separate sheets in individual holders. However, it was not until the mid 1870s that any roll-film holder sold in anything but tiny quantities. It was ten more years before roll films became firmly established. George Eastman was responsible. From 1885 he sold the Eastman Walker Roll Film Holder, which could be fitted to most cameras. What ensured its success was the general availability and excellent quality of the rolls of negative paper he made for it. A year later he made stripping film; the paper was a temporary support for the sensitive layer which could be transferred to a transparent base such as a sheet of glass.

Box cameras

In 1888 George Eastman sold a camera with the roll-film holding and winding mechanism built in. It was a leather-covered box with the simplest of controls and came ready loaded with enough film for one hundred circular negatives 2½ inches (64mm) in diameter. Eastman invented a name for it which would sound much the same in most of the countries of the word. The name was Kodak. With the camera came a unique service. Eastman's company would receive the camera by post, remove and process the film and return the prints with the camera loaded with another roll of film. It was a tremendous success. The introduction of celluloid film in 1890 boosted its popularity.

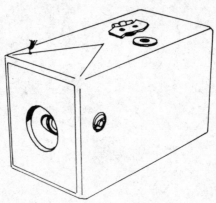

Fig. 12. The first Kodak camera.

Naturally other camera makers took notice. One early English camera to use Eastman's film was the Luzo. In contrast to the leather-covered Kodak, it was a polished mahogany box. One of Eastman's American competitors, the Blair Camera Company, and its subsidiary, the Boston Camera Manufacturing Company, introduced a couple of features which were an advance on Eastman's cameras. They put the spools on the lens side of the film track and so reduced camera length by about a third. The film itself was backed with opaque paper; individual negative positions were marked by numbers on the back of the film which could be seen through a red window in the camera body.

Eastman included these features in a camera he introduced in 1895, a small box camera taking pictures 2 by 1½ inches (51 by 38 mm), called the Pocket Kodak. It cost £1 1s. Rather than continuing to pay royalties, Eastman bought out his competitors. Between 1895 and 1900 Eastman sold large numbers of Pocket Kodak cameras and its larger brothers, the Bull's Eye and Bullet cameras. Building on these solid foundations, Eastman wanted to expand his market, not only for cameras, but for film and paper as well. If cameras were too dear, people did not buy film! So, in 1900, he brought out a much cheaper roll-film box camera. The body was stiff cardboard rather than wood. In place of a viewfinder, lines forming a V were embossed in the top of the camera to give an indication of the angle of view. At 5 shillings it was a bargain. It was the very first Brownie camera. The name came from characters in a children's story book which was popular in the USA at the time. The first Brownie took a film giving six 2¼ inch (57mm) square pictures. A year or so later the number 2 Brownie was introduced, complete with viewfinder, taking 2¼ by 3¼ inch (57 by 83 mm) pictures. Even larger sizes followed but the number 2 became the firm favourite. Kodak were still selling box-form Brownie cameras, taking 2¼ by 3¼ inch negatives, around·1960.

Following the Brownie camera's commercial success, British manufacturers were quick to bring out competitive models. G. Houghton and Sons sold the Scout and W. Butcher and Sons the Maxim. These companies, both before and after their merger, were quite successful with their box cameras, many of which were subsequently sold under the Ensign trade name.

After the First World War Goerz in Germany made some stylish box cameras, which Zeiss Ikon continued after the 1926 merger. Perhaps the highest-quality box camera made was the Zeiss Ikon Box Tengor. It had an all-metal body and a faster than normal lens. From the 1930s it was made in sizes which were smaller than was customary for box cameras. Both took sixteen pictures, rather than eight. One gave 2¼ by 1¼ inch (57 by 32 mm) pictures on 120 roll film, and the smallest of all, the Baby

Box Tengor, took 1¼ by 1½ inch (30 by 40 mm) negatives on 127 film.

Although the basic appeal of box cameras was their ease of use, most manufacturers, at one time or another, widened their scope. A push-pull strip, with two or three different-sized holes in it, provided a variable aperture for exposure control. A favourite refinement was the portrait attachment. This was a slightly positive lens, mounted at the end of a short lever or sliding bar, which was moved into the light path for head and shoulder pictures. To improve the rendering of clouds on black and white film, a yellow filter was sometimes included.

Around 1930 box cameras went through a colourful phase when both Kodak and Ensign sold them in a range of colours. The Brownie was available in red, blue, grey, brown, green and a darker red. Even fancier were the Beau Brownie cameras, which had Art Deco front panels.

Box cameras were attractive as premium offers to encourage sales of magazines and cigarettes. They were exchanged for coupons. For this purpose Kodak made the Hawkeye camera, which was practically indistinguishable from the Brownie. Other companies to supply them were Ensign and Coronet.

Brownie cameras were a little smaller from 1933 following the introduction of 620 film in the previous year. Although it still gave eight pictures on a reel, the 620 spool was much slimmer than the spool used for 120.

Folding roll-film cameras

Early roll-film cameras were as simple as box cameras with slow cheap lenses and little exposure control. With time, they blossomed to become one of the most sophisticated cameras of their day. Box cameras remained humble until the end.

In a way, the first folding roll-film cameras were plate cameras equipped with Eastman Walker Roll Film Backs. In the early 1890s some cameras were made which looked like typical hand or stand models except for longer than usual bodies. The extra space accommodated the roll-film holder. These were the Folding Kodak cameras, made in a number of sizes up to whole plate, 8½ by 6½ inches (216 by 165 mm). Blair made the Folding Kamaret from around 1893, with spool holders built into the body. As in his box-form cameras the spools were in front of the film aperture and this made the camera much smaller than the Kodak.

Following the use of paper-backed film by Eastman in 1895, two quite different cameras were announced in 1897. The first, the Cartridge Kodak, looked like a hand or stand folding camera. It was rather bulky with a leather-covered mahogany body; any exposed woodwork was french-polished. Like the Kamaret, which it resembled, it had built-in film spools. But, by sliding a

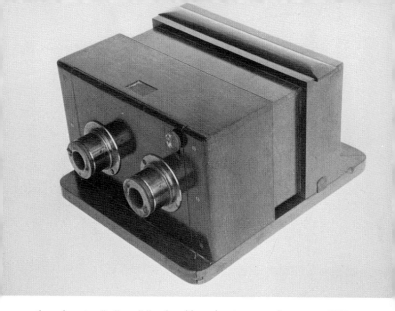

1. *A wet collodion sliding box binocular stereoscopic camera, 1860s.*
2. *Making parts for wooden cameras at Houghtons Limited, around 1908.*

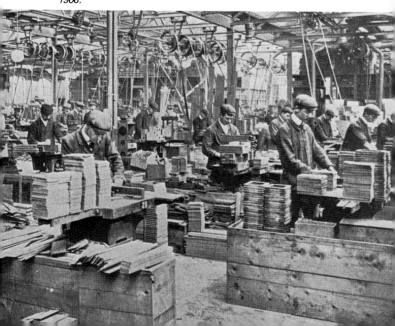

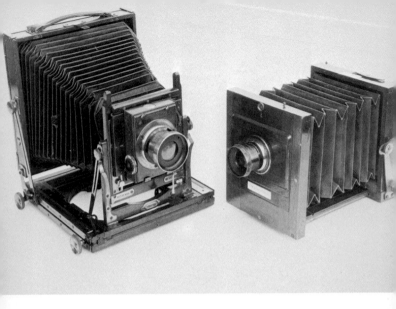

3. The Triple Victo, a taper bellows camera about 1905, and Lancaster's International of 1888.
4. The Victo and International cameras partially folded.

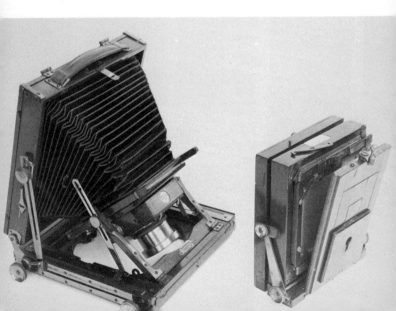

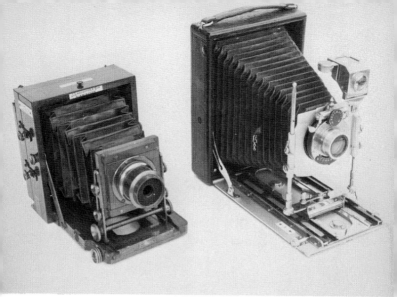

5. (Left) A quarter plate Lancaster Instantograph of 1896 and (right) a half plate Minimum Cameo camera by W. Butcher and Son Limited, around 1905.

6. (Left) A Junior Sanderson quarter plate camera, 1904, showing maximum rising front. (Right) The swing front demonstrated by a Regular Sanderson, about 1910.

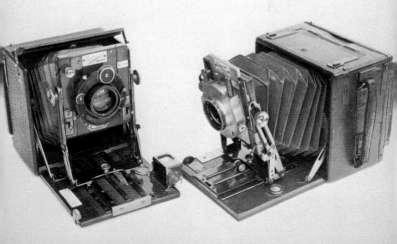

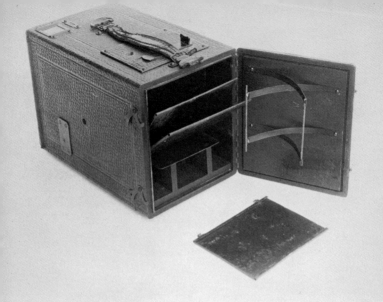

7. The rear door of a magazine plate camera opened to show the plate-holding sheaths.
8. The Frena, about 1900, opened to show the holder for the edge-notched celluloid sheet films.

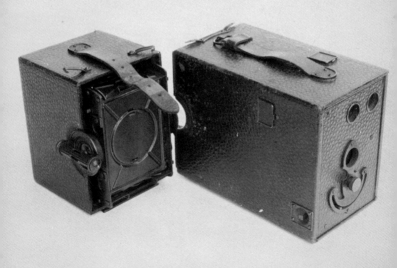

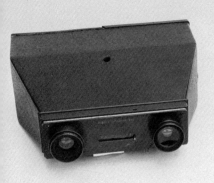
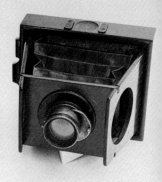

9. Early hand-held cameras. (Left) The Binocular camera by the London Stereoscopic Company. (Right) Shew's Eclipse. Both mid 1890s.
10. Folding plate cameras. (From left) A Contessa-Nettel Fiduca, a Patent Etui and Newman and Guardia's New Special Sibyl.

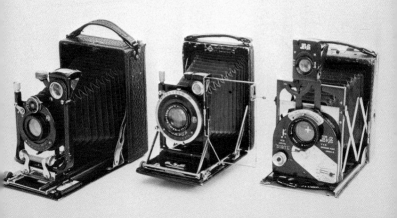

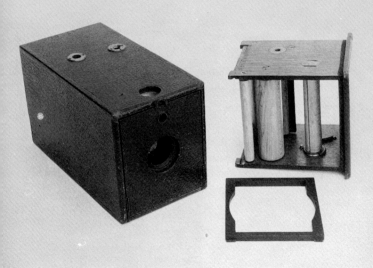

11. A Number 2 Kodak camera, around 1890, with the roll film container removed.
12. (From left) A Number 1 Folding Pocket Kodak camera and a Number 4 Cartridge Kodak camera, both about 1900.

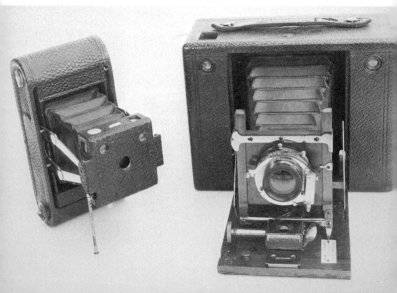

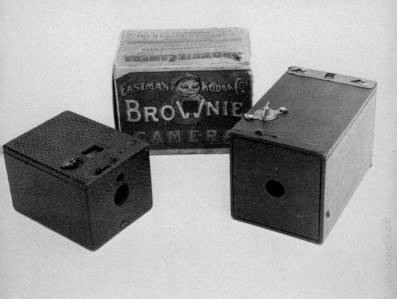

13. (From left) A Pocket Kodak camera, 1898, and a Number 1 Brownie camera about 1902.
14. (From left) The Weno camera by the Blair Camera Company and a Number 3 Folding Pocket Kodak camera. Early 1900s.

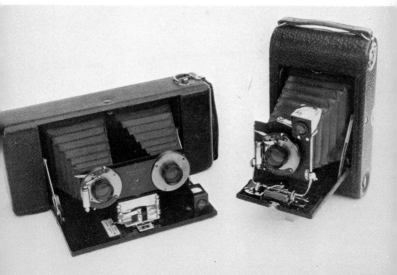

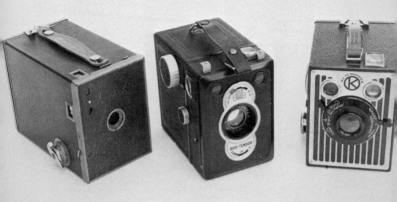

15. (From left) A Number 2 Brownie camera, 1930, and a Box Tengor and Six-20 Brownie B from the late 1930s.
16. (From left) A postcard-size roll-film camera, an Icarette and a Super Ikonta. See page 69.

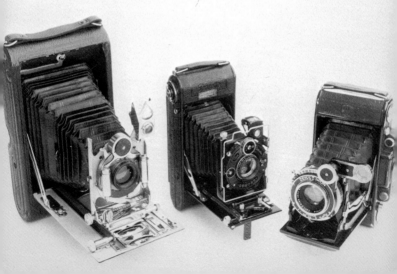

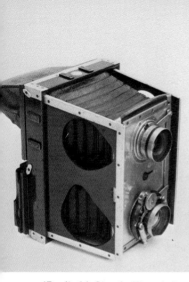
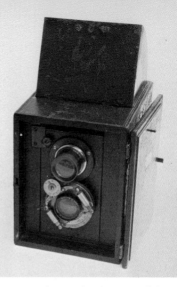

17. (Left) Shew's Xit twin-lens camera; the top lens was used for viewing. (Right) The Ross Twin Lens camera, which had reflex viewing. Both around 1900.
18. (Left) Adams's 5 by 4 inches (125 by 100 mm) single-lens reflex and (right) the Miral by Talbot and Eamer; both about 1902.

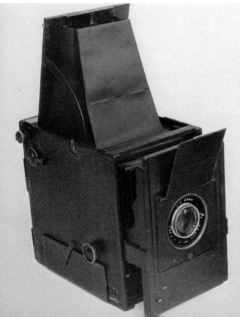
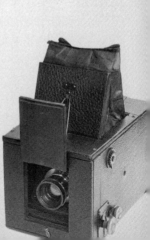

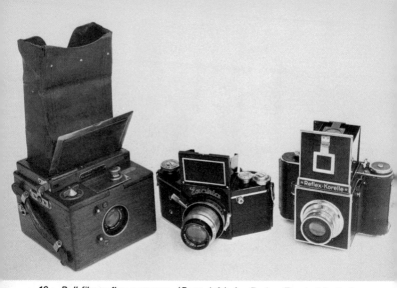

19. Roll-film reflex cameras. (From left) An Ensign Tropical in teak, around 1928, and a VP Exakta and a Reflex-Korelle from the later 1930s.
20. (Left) A Tele-Graflex and (right) a Mentor folding single-lens reflex camera, both from the early 1920s.

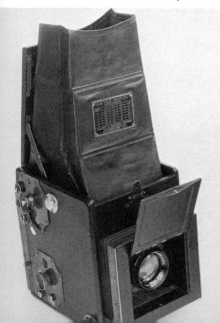
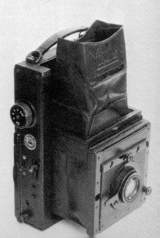

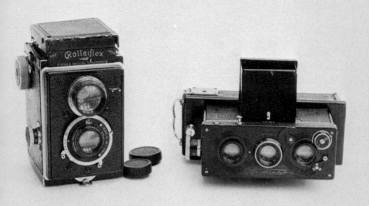

21. *(Left) An early Rolleiflex, around 1930, and (right) a stereoscopic camera with reflex viewing, the Stereflectoscope by Voigtlander, late 1920s.*

22. *(From left) A Rolleiflex Automat, 1938, a Zeiss Ikon Ikoflex, 1936, and a folding Welta Superfekta, late 1930s.*

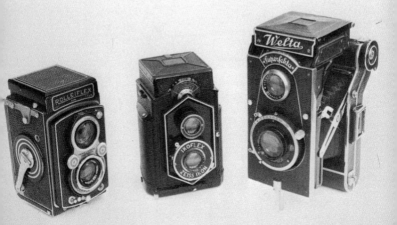

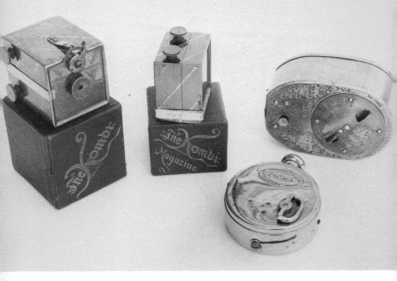

23. (From left) A Kombi camera and magazine and a Presto camera, late 1890s. (Below) Houghton's Ticka, about 1910.
24. Vest pocket cameras for 45 by 60 mm plates. (From left) An Ernemann, a Goerz Tenax and a Zeiss Ikon (Contessa Nettel) Duchessa.

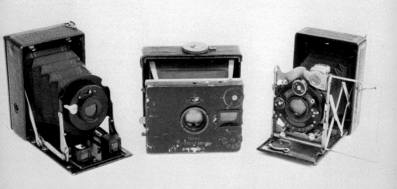

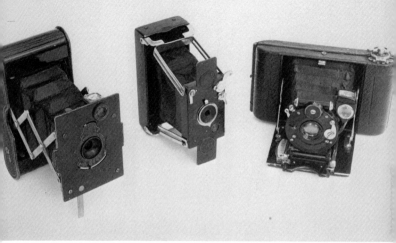

25. Vest-pocket roll-film cameras. (From left) A Vest Pocket Kodak, an Ensignette and a Butcher's Watch Pocket Carbine, all around 1914.
26. Early 35 mm cameras. (From left) A Leica camera of 1928, a Leica III and a Contax I, both about 1934.

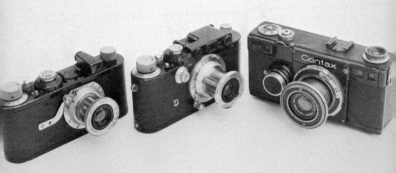

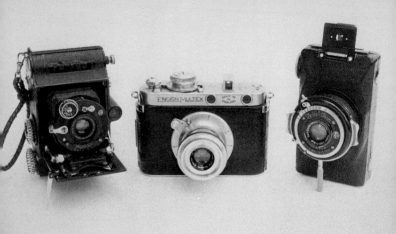

27. 30 by 40 mm on 127 roll film, 1930s. (From left) A Voigtlander Perkeo, an Ensign Multex and a Zeiss Ikon Kolibri.
28. Folding 35 mm cameras from the 1930s. (From left) A Retina II, a Retina I and a Certo Dollina.

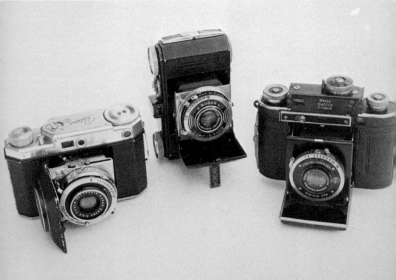

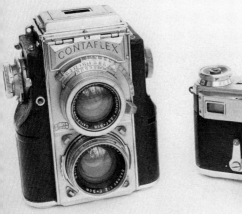
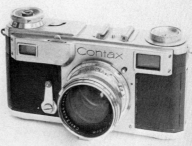

29. Cameras of the highest quality. A twin-lens Contaflex, the first camera with built-in photoelectric exposure meter, and a Contax II. From the late 1930s.
30. (Left) The Agfa Karat had semi-automatic film loading using special 35 mm film cassettes. The Robot had clockwork automatic film advance. 1930s.

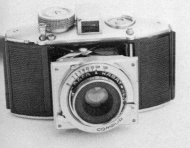
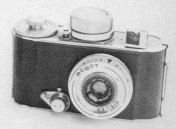

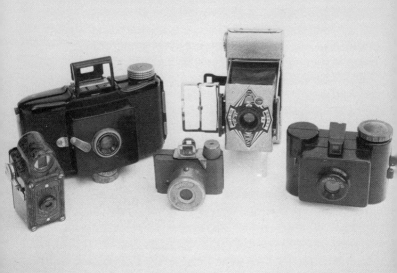

31. Small cameras taking special-size roll film in the 1930s. (From left) Coronet Midget, Kodak Bantam, Ulca, Ensign Midget and the Sida.

32. (Left) A Goerz Tenax and (right) a Zeiss-Ikon Maximar. See page 69.

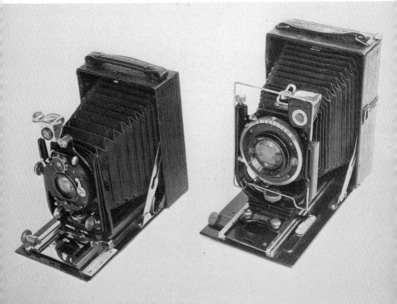

catch beneath the bellows, the flat back could be replaced by another with a recess for taking a viewing screen or double plateholder. The camera could be bought just for use with roll films; plate equipment cost extra. The term 'Cartridge' distinguished paper-backed film from the uncovered roll film used in the first Kodaks and Eastman Walker holders. Cartridge Kodak cameras were very popular and went through a number of model changes. Three models were available: Number 3 took 3¼ by 4¼ inch (83 by 108 mm) pictures; Number 4 was larger at 4 by 5 inches (102 by 127 mm); the Number 7 took 7 by 5 inches (178 by 127 mm).

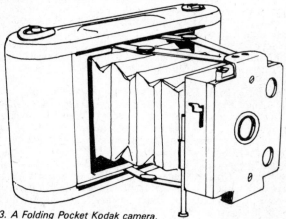

Fig. 13. A Folding Pocket Kodak camera.

The second folding roll-film camera to be launched by Kodak in 1897, the Folding Pocket Kodak, was particularly influential. When collapsed, it was a relatively small flat camera, just under 7 inches (178mm) long, with rounded ends. The lens panel pulled forward on four spring-loaded struts. Good-quality black grained leather covered the body; the bellows were in red leather. As with a box camera, the focus was fixed and the shutter had only one speed, but three apertures were provided as holes punched into a sliding metal strip. It cost £2 2s. It introduced the 2¼ by 3¼ inch (57 by 83 mm) picture size, later to become one of the most popular. Smaller photographs were made by the Number 0 model, which came out in 1902, and larger ones by the Number 1A. Both were built on similar lines to the Number 1.

Very popular sizes for roll-film cameras before the First World War were quarter-plate, 3¼ by 4¼ inches (83 by 108 mm), and postcard, 3¼ by 5½ inches (83 by 140 mm). Kodak called

these Numbers 3 and 3A respectively for their Folding Pocket Kodak cameras. The Number 3 FPK, as it was often abbreviated, was first sold in 1900 and set the style for nearly all roll-film folding cameras for half a century. When closed, it resembled the flat, rounded-end body of the Number 1 FPK. The baseboard, which completely covered the lens when the camera was folded, was hinged along the short side of the body close to one end. When pulled forward it was locked in position by side struts. Rails in the baseboard formed a track along which the front of the camera was pulled into position for taking photographs. It was provided with a brilliant reflecting viewfinder and a rising front. Number 3 and 3A FPKs were available with higher-quality anastigmat lenses and sometimes with better shutters. Indeed some leading lens manufacturers, such as Zeiss, Ross and Goerz, advertised Kodak cameras fitted with their optical equipment.

Postcard size was not the largest of these early Kodak cameras. The Number 4 Folding Pocket Kodak took 4 by 5 inch (102 by 127 mm) negatives; that is 20 square inches (129 sq cm) of film, almost as much as the total negative area of a twenty-exposure roll of 35mm film today! Largest of all was the 4A. The name 'Pocket' was dropped for this very large camera, for no pocket would have been big enough. It was just a Folding Kodak. The picture size was close to half plate at 4¼ by 6½ inches (108 by 165 mm).

The success of the early Kodak cameras produced a number of competitors. Some followed the Cartridge Kodak style, but more copied the popular Folding Pocket Kodak camera. Lizars, in 1899, had a Challenge camera very much along Cartridge Kodak lines with the advantage that a special back was not needed when using plates. In 1902 Houghtons made a roll-film version of their hand or stand Sanderson, but it was not popular and was soon discontinued. Lizars also made the more pocketable type of camera under the trade name Challenge Dayspool. They were finished in leather or else the mahogany was french-polished to give them a most attractive appearance. Tylars sold the TEB, Fallowfields the Falloroll and Lancasters the Filmograph. Judging from the few of these still to be found today, compared with the comparative abundance of Kodak cameras, not many could have been sold.

Most of the folding roll-film cameras of the early 1900s could also be used with plates. Either the camera back had grooves to take a single metal slide or it was interchangeable with a plate back. Kodak's biggest competitors in Britain, Houghton's Ensign cameras and Carbines from W. Butcher and Sons, were both able to take plates. A plate adaptor, focusing screen and three metal plateholders for the popular quarter-plate Butcher's Carbine cost 13s 6d in 1904; the camera itself was £3 12s 6d.

One or two cameras were very cleverly designed. At first glance,

they look exactly like conventional rounded-end roll-film cameras. By pulling and turning a catch or two here and there, the whole centre section of the camera could be pulled away from the roll-film chamber, leaving what appeared to be a square-ended folding plate camera. With the addition of a suitable back that is exactly what it became. Well known models were Marion's Iso Duplex and the St Etienne Universal camera. It was not necessary to finish the film before switching to plates because a cover could be slipped over it, to keep it in the dark, before the roll-film chamber was detached. With Busch's Freewheel camera, it was not even necessary to detach the film holder; the plateholder slipped into a groove between film and lens.

Early roll-film users complained that the style did not allow them to focus and compose their pictures on a ground glass screen. Kodak offered a compromise with their Screen Focus Kodak camera. It looked like the Cartridge Kodak, but the whole film-holding assembly could be shut off, with a light-tight cover, and be swung over the top of the camera. This allowed a focusing screen to be fitted. When the picture was well focused, the procedure was reversed; the screen was removed, the roll holder swung back and the cover taken out. You had to remember to close the shutter again after focusing! It was barely worth the trouble and the system was not widely adopted.

At the end of the Victorian era and the start of the Edwardian period there was a reawakening of interest in stereoscopic photography, though many more people bought stereoscopic photographs, ready mounted for viewing on stiff card, than made the pictures themselves. Millions were sold, either singly or in sets, often presented in boxes finished with imitation spines and titles to look like books. However, the folding roll-film camera lent itself very well to stereoscopic photography. Unlike plates, where special sizes were needed, the long length of roll film was ideal for making side by side pairs of photographs. Some manufacturers sold stereoscopic cameras which looked rather like two single cameras joined together on a common body. Most had two separate bellows. A typical example is the Weno camera, made by Blair and sold in Britain by Kodak Limited.

In a class by themselves were the de luxe cameras, made in relatively small quantities and finished by hand by such firms as Newman and Guardia and Adams. The Newman and Guardia Roll Film Sibyl was made in three popular sizes, the Baby Sibyl taking 2½ by 1⅝ inch (64 by 41 mm) pictures, the New Special Sibyl, which took a 120 roll, and the New Ideal, which took quarter plate. The construction was very much the same as the equivalent plate models with criss-cross struts either side of the bellows. Prices in 1914 give some idea of the quality. The New Ideal, with an f4.5 Xpres lens, cost £21. This compares with £10

for the Special Kodak, a de luxe version of the Folding Pocket Kodak, with an f6.3 Zeiss Tessar lens in a Compound shutter. The rival to the Sibyl was Adams's Vesta camera. It, too, had lazy tong strutting and a viewfinder which adjusted with the rising front to show the corresponding field of view.

Between 1900 and 1914, although the general style remained much the same, there were some significant detail changes in roll-film cameras. In the earliest models, the support for the lens panel was probably made from wood; the brasswork was lacquered or nickel-plated. Red was a very common colour for bellows but, towards 1910, black bellows were clearly the vogue. By then the lens panel supports were usually metal. Throughout most of the first decade of the century they were fabricated from several pieces of metal strip and rod all welded or screwed together, and usually nickel-plated. Mass-production techniques were increasingly used and, from around 1907, a cast light metal U-shaped stirrup-like support came into use. At first it was found in the more expensive models but, by the First World War, even the cheaper end of the range had them. So, in little more than ten years, roll-film cameras, following the same path as folding plate cameras, went from red bellows, polished wood and lacquered brass to black leather bellows, black woodwork and black enamel relieved only by nickel-plated brightwork.

From 1914 many Kodak cameras had a long narrow hinged door in their backs which carried a slender metal stylus. This was the Kodak Autographic feature. Autographic film had a layer of opaque paper between the celluloid and the usual backing paper. In use, the little door was opened and, with firm pressure on the stylus, a few words were written directly on the backing paper. Where the paper was scribed it lost its usual opacity and light passed through the writing to the film below. On development, the words appeared as black letters in the spaces between the negatives. The advantages seemed enormous: a permanent record could be included on every negative of names, dates, places and so on. But the information did not appear on the print and so its value was lessened. Autographic film sold at the same price as ordinary roll films. Millions of cameras with the Autographic feature were sold between 1914 and 1933, when the system was discontinued. It is possible to come across Kodak cameras, clearly made before 1914, which have the Autographic trap door. Probably their owners bought a replacement back from Kodak, who sold them, from 1914, for updating earlier models.

The supply of German cameras to Britain ceased at the outbreak of war in 1914. This caused problems for W. Butcher and Sons, since many of their cameras had been made for them in Germany. They set up a joint manufacturing plant with Houghtons in 1914, although their designs, trade names,

advertising and selling remained separate for a further ten years. However, imports still arrived from the USA. A particularly interesting one was the Autographic Kodak Special camera of 1916. It was the first time a camera was sold with a coupled rangefinder. The Number 1A and Number 3A Autographic Kodak Special cameras looked very much like the typical folding bellows cameras of the day. The difference lay in an assembly of mirrors and a shallow prism placed just below the shutter. The rangefinder was a little awkward to use, but it was accurate. This time a good idea was not copied and it was not until around 1930 that coupled rangefinders came into widespread use.

In addition to Kodak, other American manufacturers such as Ansco, Wollensak and Ilex supplied cameras, lenses and shutters to Britain during and after the war. Indeed, following the formation of APM Limited in 1921, through the amalgamation of several old British companies, Ansco cameras were imported and sold under the APM label.

German manufacturers started to advertise their cameras in Britain again in the early 1920s. Voigtlander and Goerz, who were well known from before the war, were joined by Contessa-Nettel, Ica and Ernemann. Some of them were less familiar to the British camera buyer, though they may have made cameras before 1914 which were sold in the United Kingdom under British labels.

The general appearance of postwar cameras had not altered much in ten years or so. However, camera bodies were mostly made entirely of metal, rather than wood, and a folding full-frame wire viewfinder was often fitted around the lens panel, with a hinged rear peep sight on the body. Moulded plastics had been employed for camera parts, such as knobs, for many years. Indeed a cheap French stereoscopic camera, the Glyphoscope, had a moulded body back in the 1900s. But it was only from the late 1920s that moulded Bakelite cameras were made in any quantity. The Rajar Number 6 by APM dates from 1929. It was a crudely made strut-form folding roll-film camera in black Bakelite. Kodak made a similar camera in brown plastic, about the same time, called the Number 2 Hawkette. Both cameras were only obtainable in exchange for advertising coupons.

Self-erecting fronts started to reappear in the 1920s. The Pocket Kodak Series II cameras of 1923 were self-erecting, though photographers must have been just as happy at pulling the lens board out along baseboard tracks, for the older system was used for a few years yet in new camera introductions.

The 1930s was a golden age for folding roll-film cameras. At the start of the decade, the 35mm miniature camera was available but still regarded by many as a curiosity. Plate cameras were still popular with keen amateurs, particularly with roll-film or film pack adaptors. But their numbers were declining fairly quickly.

Around 1930, Ilford Limited, Agfa and Kodak introduced new roll films with good tonal rendering, fine grain and wide exposure latitude—qualities previously obtainable only from plates.

The main advances in roll-film cameras in the 1930s were the use of coupled rangefinders, sixteen or twelve pictures from a roll intended only for eight, eye-level optical viewfinders and body-mounted shutter releases. Satin-finished chrome plate was used for more expensive models from 1936 and spread to cheaper cameras within a few years. By the end of the decade at least one camera had a built-in photoelectric exposure meter.

From 1930 Agfa sold their Speedex and Standard cameras. The Speedex had self-erecting fronts; the Standard did not. However, it was one model of the Standard which was probably the first camera to have an eye-level coupled rangefinder. It was linked to the focusing track by a short length of very flexible chain. It sounds crude but it worked well. Another early coupled range-finder camera was the Voigtlander Prominent. It was an ungainly camera covered with knobs and projections. In addition to the rangefinder, it had an optical extinction exposure meter. It was on the market for only about three years.

Zeiss Ikon were particularly successful with their roll-film cameras. They continued with a few pre-merger cameras like the Icarette. This was not a self-erecting camera and was certainly intended for the serious amateur photographer. Beautifully made and finished in the finest leather, it came in single and double extension models, both of which could be used with plates. They were not cheap. A double extension model of the 2¼ by 3¼ inch (57 by 83 mm) size cost £16 12s 6d in 1932, with an f4.5 Tessar lens in Compur shutter. At the other end of the range the cheaper, but still well made, Nettar camera cost only £7 5s with a Nettar lens in Compur shutter. In between came the Ikonta cameras, which, with their excellent lenses, were amongst the best roll-film cameras available.

The coupled rangefinder of the top-of-the-range Super Ikontas was rather unusual. To one side of the lens was a folding bar terminating in a glass disc. The disc was really a pair of glass prisms which bent the rays of light to the rangefinder window as the lens was focused. The Super Ikonta was made in four sizes taking eight pictures on a 116 film, and eight, twelve and sixteen pictures on 120. The most expensive, the 2¼ inch (60mm) square model, also had the fastest lens, an f2.8 Tessar. The price in 1939 was £30 7s 6d.

At the same time Voigtlander made two popular cameras, the Bessa and Rangefinder Bessa. They were elegantly styled and easy to use. In contrast to Voigtlander's earlier Prominent, the Range-finder Bessa was streamlined. Focusing with the coupled rangefinder was particularly easy since the control knob was on

the body rather than on the lens or baseboard.

From around 1931 some cameras took sixteen pictures on a roll made for eight. To achieve this, two red windows were used in the back of the camera. Picture number one was wound to the first window for one exposure and to the second window for the next shot. Some cameras were dual format. A separate mask could be placed in the film aperture to reduce the negative size to give twelve or sixteen rather than eight exposures. Sometimes hinged masks were included in the film chamber which flipped over, each covering one side of the picture area. The viewfinder had a corresponding mask to reduce the field of view.

The Ensign Selfix 220 had hinged body masks which allowed the photographer to choose between twelve 2¼ inch (60mm) square pictures or sixteen 2¼ by 1⅝ inches (60 by 41 mm). The viewfinder had a detachable top with a square opening at one end and an oblong one at the other. When the format was changed the top was pulled off and put back the other way around. Ensign also made coupled rangefinder cameras under the Auto-Range trade name. The rangefinder on the eight on 120 model looked as though it was an afterthought. It was screwed on to the side of a non-self-erecting camera of conventional appearance. In use it was quite delightful. The usual focusing knob was replaced by a short lever, operating through an arc, and geared to the focusing track. The lever travelled the full focusing range, from infinity to a few feet in one short movement. The Auto-Range 220 was the rangefinder version of the Selfix 220. It too had radial lever focusing and was a fine-looking camera in satin chrome finish with the rangefinder spot combined with the viewfinder.

Kodak, in the 1930s, continued with their well made cameras for the snapshooter and less demanding amateur photographer. 620 film was introduced in 1932. The picture size was the same as with the 120 spool, but the centre core was narrower to give a smaller overall diameter. Consequently 620 camera bodies were slimmer than their 120 counterparts. The early 620 Kodak cameras had a most elegant black enamel and nickel-plate decorative finish. The Kodak Regent, which also took 620 film, was another elegant camera from their German factory. It was well equipped with a coupled rangefinder and f4.5 Tessar lens.

Towards the end of the decade the photoelectric exposure meter, which was sold as a separate instrument from around 1933, was incorporated into the 2¼ inch (60mm) square model of the Super Ikonta. Kodak went a stage further with their Super Kodak 620 camera. It too had a built-in selenium cell exposure meter but, instead of setting shutter and diaphragm by hand to the readings given by the meter, a completely automatic mechanism set the aperture for correct exposure. So, in 1939, Kodak had produced the world's first fully automatic exposure camera.

5. Reflex cameras

The early photographer could compose and focus his picture on a ground glass screen. No doubt he learned to live with the upside-down view but there must have been times when he wished it had been the right way up. Hand-camera pioneers revelled in their freedom from the tripod but focusing by scale and composing in a tiny viewfinder were no match for the ground glass screen at getting the picture sharp and well arranged. The ideal was a hand-held camera which allowed viewing on a large screen and focusing with the image the right way up.

The answer lay with the reflex principle. Behind the lens, at an angle of 45 degrees, went a surface silvered mirror which reflected the view on to a horizontal, well hooded screen. With just one lens in the camera, used for focusing and taking, the mirror had to be moved out of the way just before making the exposure. An alternative was to place a second lens above the first, the upper one used for viewing and the lower for making the picture.

The single-lens reflex camera

The single-lens reflex was designed as early as 1861 by Thomas Sutton but few cameras were manufactured to his design. As we have seen, it was the introduction of the dry plate in the 1880s which spurred on development of the hand camera. Several single-lens reflex cameras were then devised.

The designers had a tricky problem to solve. Light could not be allowed to fall on to the surface of the plate during focusing but had to do so an instant after the mirror was swung out of the way. One answer was to fix an opaque blind to the moving edge of the mirror. In the blind was a narrow gap. As the mirror flew up, the blind followed, making an exposure as the gap passed the lens. Talbot and Eamer of Liverpool used this simple arrangement in their Miral camera of the late 1890s. Other early single-lens reflex cameras which enjoyed limited success were the Vanneck, which was sold by W. Watson and Sons in 1890 and C.R. Smith's Monocular Duplex of the middle 1880s.

As the focal plane shutter came into regular use, it provided an elegant means of keeping the plate in the dark until the mirror was safely out of the way. Loman's camera, imported from Holland, was one of the first to incorporate it into a single-lens reflex. Following its introduction in the early 1890s, other focal plane reflexes followed. A well regarded model, the Gambier Bolton, sold by Watsons, was named after a well known photographer whose pictures of animals were frequently published.

Most of these early single-lens reflex cameras had rather long bodies which completely enclosed the focusing rack. About 1900

a new design was used which set the basic shape of the plate reflexes for half a century. The body was now a cube; the lens panel racked out on bellows which projected from the front of the camera. The square shape of the back allowed the plateholder to be inserted vertically or horizontally for upright or landscape pictures.

The first of the new design were the Graflex, made in the USA by Folmer and Schwing, and the Adams Reflex from Britain. The Graflex was made in a variety of models for over fifty years. It was well known for its reliable shutter. Of focal plane design, the blind had a number of slits of different widths, which, combined with varying tensions of the return spindle spring, gave a wide range of shutter speeds. The Adams Reflex used a pair of blinds with variable slit width. The Reflex was soon followed by two similar models from Adams, the Videx and the Minex. Only the best materials and craftsmanship went into their manufacture. In 1910 the Minex cost £36 fitted with an f4.5 Tessar lens. Adams's rival in the field of quality cameras was Newman and Guardia, well known at the time as N and G. A most useful accessory in their N and G Reflex was a binocular magnifier, with intra-ocular adjustment, which fitted to the top of the hood for critical focusing.

The years between 1900 and 1914 were a golden age for reflex cameras. Most of the leading manufacturers offered them for sale. At first they were expensive but, as their popularity grew, cheap but robust models were sold which worked well even if they did lack the refinements of the dearer cameras. Houghton's Ensign Reflex was sold from about 1908. Fitted with a reasonable anastigmat lens, it cost around £10 and £12. Following the basic cube shape for the body, the back was detachable and reversible for portrait and landscape pictures. The ground glass of the viewfinder, as in all the cheaper cameras, was marked with lines representing the vertical and horizontal formats. In contrast the Minex, for example, had a revolving back which automatically changed the viewfinder mask as it was turned. Thornton Pickard, another British camera manufacturer, launched the Ruby Reflex at about the same time as the Ensign. Because of their relatively low price, £12 for a quarter-plate model in 1910, they were as popular as the Ensigns. Many models were made up to about 1940. An interesting variation came in the Royal-Ruby Reflex, which had a front like a hand and stand camera allowing the use of rising and tilting front.

The camera which came to epitomise the plate reflex was the Soho by Marion and Company. It was well made, reasonably priced, and had a very smooth shutter and mirror action. This last feature came from a patented assembly made by Kershaw and Company of Leeds. It was supplied to a number of other

companies who sold cameras very similar in appearance to the Soho. It can be found in the Ross Reflex, the Ledon by Dallmeyer and the Artist, which was sold by the London Stereoscopic Company.

These box-like reflexes were quite large for the size of picture they took. Attempts were soon made to make folding varieties. By 1910 there were a few on the market such as the Folding Ensign Reflex and Goerz's Folding Reflex. When folded, each was a flat box shape. With the Ensign, the front pulled forward and the mirror and screen moved from their parked position and locked at 45 and 90 degrees to the lens. The Goerz worked a little differently. To erect the camera, the lens, which had been facing the base, was pulled forward and upward through a right angle. Most folding reflexes were not very popular. They weighed just as much as their box-form versions and cost more.

Other folding models were the Mentor and the Ihagee but the best was probably Newman and Guardia's Patent Folding Reflex of the early 1920s. Like all their cameras, it was beautifully made and simple to set ready for taking pictures. However, it was expensive; the cheapest model cost £48 in 1925 and that went up to £58 with an f2.9 Pentac lens.

Although a few single-lens reflex cameras were made to take roll film early on, especially the Graflex, it was not until the 1920s that they became popular. Both Ihagee, with the Paff, and Houghtons, with the Ensign Roll Film Reflex, made roll-film single-lens reflexes which were virtually box cameras with reflex viewing. The lenses were f11 and the shutters had only a single speed. The Ensign was soon issued in a more refined model with an anastigmat lens and a later model, issued in 1928, was called the Speed Reflex because of its focal plane shutter operating at up to one five-hundredth of a second.

With the trend towards smaller cameras in the 1930s, Ihagee launched the Exakta in 1933. It was a small all-metal single-lens reflex with focal plane shutter and interchangeable lenses. Using the small eight on 127 format, it was much less bulky than even the smallest of the plate reflexes. By 1936 it had lever wind and built-in flash synchronisation, one of the first cameras with this feature. A 35mm version, the Kine Exakta, was launched in 1936 with a similar specification and also with bayonet mounted lenses. It started the trend towards the 35mm single-lens reflex cameras of today.

The twin-lens reflex camera

As the name suggests, two lenses were used in this second type of reflex camera, one for viewing, the other for taking the picture. This had benefits and drawbacks. With a lens dedicated to viewing, the image remained bright when the taking lens was

stopped down, and complicated moving mirrors were not needed. But the camera was much bigger than a single-lens reflex; it had to be because it was really two cameras, one mounted on top of the other. Nevertheless, until the mirror and shutter mechanisms of the single-lens form were perfected, the twin-lens was the more popular, particularly between the early 1880s and 1900.

One of the first twin-lens cameras did not have reflex viewing. The ground glass screen was vertical, without a mirror between it and the lens. It was tiny enough to hold comfortably in the hand with the screen at eye level. The camera, which sold from 1881, was the Academy, by Marion and Company. It took plates only 1¼ inches (32mm) square in the smallest model.

From 1890, the London Stereoscopic Company made much larger cameras, which they called the Twin Lens Artist Reflex camera. They ranged in plate size from 5 by 4 inches (127 by 102mm) at £15 15s up to 8½ by 6½ inches (216 by 165mm) for £35. 'As used by HRH the Princess of Wales' claimed the advertisement. It was a tall rectangular box topped by a small folding hood. The viewing lenses on the early twin-lens reflexes were rather slow, around f8, and, unless the screen was well hooded, the image was dim.

Newman and Guardia made an improvement by totally enclosing their screen in a box-like hood. The only way of seeing the ground glass was by peering down a tube mounted on top of the hood. One of the more successful of these early twin-lens reflexes was made by Ross, who called it the Portable Divided Camera. Originally fitted with a roller blind shutter in the early 1890s, a trimmer version sold in the twentieth century with the smaller between-the-lens shutter. Again it was not cheap. The smallest size, taking 3¼ inch (83mm) square plates, cost £16. Ross were still advertising the camera in the *British Journal Photographic Almanac* for 1914, by which time the twin-lens reflex had dropped from favour. It was the last of the line.

One other twin-lens camera was advertised in the same book, the Folding Twin Lens Camera by Thornton Pickard. It looked like a folding plate camera of double height; each lens had its own bellows. There was no mirror, so the camera was focused at eye level, like the Academy. J. Shew used the same principle with a somewhat earlier camera, a twin-lens version of their famous Xit camera. The viewing screen could be replaced by a plateholder allowing stereoscopic pictures to be taken. Since the viewing lens had no shutter, only time exposures would have been possible when the camera was used in this way.

It was a stereoscopic camera which brought a revival of interest in the twin-lens principle. Sold from 1914, the Voigtlander Stereflectoscope was an all-metal camera taking the smaller standard-size stereoscopic plate of 1¾ by 4¼ inches (45 by 107

mm). With the taking lenses a couple of inches apart, there was room between them for a third lens for viewing, topped by a reflex viewing screen. For focusing, the three lenses moved together on a common panel. Franke and Heidecke, another German company, started to make a very similar plate stereo-scopic camera in 1922. They called it the Heidoscope and followed it, in 1926, with a roll-film version, the Rolleidoscope.

It was then a simple step to leave off one of the taking lenses and make a modern roll-film version of the twin-lens reflex. The Rolleiflex, of 1928, was developed in this way from the Rolleidoscope. Many of the parts, such as knobs and the hood, were the same in each camera. It took 2¼ inch (57mm) square pictures on a six-exposure roll film. The Rolleiflex was an immediate success. By comparison with the single-lens reflexes of the time it was much quicker and easier to use. It had a full range of slow speeds from the Compur shutter and a screen which remained bright at all times. Improved versions appeared steadily throughout the 1930s. A 40 by 40 mm (1⅝ by 1⅝ inch) version joined the original 60 by 60 mm (2⅜ by 2⅜ inch) format. Lever-wind film advance was added and, in 1938, film loading was made completely automatic; there was no red window at all.

Success brought imitators, though none matched the remarkable handling qualities of the Rollei. Voigtlander sold the Brilliant, which, although it resembled a twin-lens reflex camera, did not have the lenses coupled for focusing. A later model, the Focusing Brilliant, had meshing gears surrounding the lenses so that as one was revolved it turned the other. The Superb by Voigtlander was a true twin-lens reflex camera of top quality.

In the Miniature Camera edition of the *Amateur Photographer* in June 1939 there were about a dozen different twin-lens reflex cameras taking twelve pictures, each 2¼ inches (60mm) square, on 120 film. The Rolleicord was a lower-priced and simplified version of the Rolleiflex, with knob rather than lever wind. Zeiss Ikon made a range of Ikoflex cameras and by then the Brilliant had a moulded plastic body.

Even the new-style twin-lens reflex was a little bulky and it was not long before a folding version was offered. The lens panel on these cameras could be pushed back on criss-cross struts to the camera back. When collapsed, they were not much thicker than an ordinary folding roll-film camera. The first was the Pilot Reflex, which took sixteen pictures on 127 film. Welta introduced the Perfekta, taking 2¼ inch (60mm) square shots, and the Superfekta for negatives 2¼ by 3¼ inches (60 by 83 mm). For horizontal pictures with the Superfekta, the back of the camera rotated through 90 degrees, with a corresponding change in the viewfinder mask.

The most sophisticated camera before 1940 came from Zeiss

Ikon. It was the twin-lens Contaflex camera. Although it was as big and heavy as a roll-film reflex, it took 35mm film. It was unusual in having interchangeable lenses from a standard lens with a maximum aperture up to f1.5 to a 135 mm telephoto. The viewing screen was extremely bright and a metal focal plane shutter was fitted with speeds between half and one thousandth of a second. Furthermore, the Contaflex was the first camera to have a built-in photoelectric exposure meter. It was also the dearest camera then available! In 1939, with an f2 Sonnar lens, it cost £71 17s 6d; the most expensive Rolleiflex was £31 5s.

6. Miniature cameras

Although some very small cameras were made in the wet plate era, miniature camera photography really began with the gelatin dry plate around 1880. Marion's Miniature Camera of 1884 was certainly very tiny. It took plates just 1¼ inches (32mm) square, about the same size negative as a 126 Instamatic camera. It was little more than a square-section tube, with a simple shutter in front of the lens and a single plateholder. A revised version, Marion's Metal Miniature Camera of around 1888, was similar except that its all-metal body tapered towards the lens.

Many of the cameras hidden in cravats, bowler hats, walking-stick handles and imitation books of necessity took very small pictures. The pocket watch type proved a popular form of disguised camera. Lancaster's Watch Camera of 1886 was probably the earliest. When closed, it looked like a hunter watch. On opening the case, a set of spring-loaded tubes popped up, like a collapsible drinking cup, to form a short tapering body. It is a very rare camera today even though it only cost 21s at the time. The pictures were reasonably large at 2 by 1¼ inches (51 by 38 mm).

A camera which retained its watch-like appearance in use was sold in the British Isles as the Ticka and as the Expo in the USA. It proved to be very popular in both countries even though its introduction in 1906 was later than most other disguised cameras. The Ticka cost only 8s 6d and took twenty-five exposures, just 15 by 23 mm (5/8 by 7/8 inch), on roll film in a double-ended cardboard cartridge. The lens cap, which imitated a winding knob, covered the lens, which was buried away in the 'winding stem'. Houghtons, who supplied the Ticka, sold contact printing equipment and even albums for the tiny prints. Also available was a printing box which enlarged the pictures to a more acceptable size.

The first miniature camera to use roll film also achieved considerable popularity. Sold from 1893, the Kombi was almost

cubical with a black, oxidised silver finish. Eastman Kodak provided its new celluloid roll film for the camera in lengths to make twenty-five exposures each just over an inch (25 mm) in diameter. The roll-film holder was a detachable magazine. Spare ones were available with light-tight covers but changeovers had to be made in ruby light or total darkness. The camera could also be used as a viewer if the negatives were first turned into a strip of transparent positive pictures. This was wound through the camera, a picture at a time, with the lens to the eye, after a panel had been removed from the camera's back to let light pass through. This combined role of camera and viewer gave the Kombi its name.

Other small plate and roll-film cameras of the 1890s were the Brin, Presto, Demon and Photoret.

The small 45 by 60 mm (1¾ by 2⅜ inch) plate was introduced by Jules Carpentier for his Photo-Jumelle camera of 1892. Although small for its time, the camera was certainly not pocketable. In 1902 Gaumont introduced the Block-Notes, which took advantage of the small size of the 45 by 60 mm plate. It was a folding camera, using four struts, and when collapsed was easily small enough to tuck into a pocket. The name means 'Notebook'. It was beautifully made, and it sold, with a Tessar lens, for £9 12s.

Because of the pocketability of the Block-Notes and similar cameras, the 45 by 60 mm (1¾ by 2⅜ inch) format soon became known as the Vest Pocket or VP size. Other popular strut-form VP plate cameras made around 1910-15 were Goerz's Tenax, the Ica Bebe and cameras made by Murer in Italy and sold under a variety of names in the United Kingdom such as the Salex and Sprite.

Tiny VP plate cameras were also made as scaled-down versions of traditional folding baseboard cameras. Newman and Guardia made the Baby Sibyl, Ernemann sold a range of self-erecting cameras and Ica supplied Butcher's Watch Pocket Carbine. Their popularity continued until the late 1920s, with some models, such as the Baby Sibyl, continuing until the Second World War. Kodak, with their box-form Pocket Kodak of 1895, had already popularised small roll-film cameras. Surprisingly, the Number O Folding Pocket Kodak of 1902, which took 2½ by 1⅝ inch (64 by 41 mm) size pictures, was not much favoured. Because the spool had a thick core, the camera was not very slim and this may have limited its appeal.

Houghtons were the first to take advantage of the popularity of vest pocket plate cameras when they brought out a roll-film version, the Ensignette, in 1909. When closed, it was smaller than today's full-frame compact 35mm cameras but the picture size was 2¼ by 1½ inches (60 by 38 mm), a little smaller than the VP plate format. Like many other slim cameras, the Ensignette used

struts to keep the lens board in place when it was pulled forward ready to take pictures. Its small dimensions were made possible by the narrow metal core of the film spool. A larger version, the Model II, came out a few years later, taking 3 by 2 inch (76 by 51 mm) pictures, again on a special size of roll film.

Kodak responded to the success of the Ensignette by launching a camera along similar lines in 1912. It used lazy tong supports in place of struts and the spool, also, had a slim metal core. The picture size was closer to VP plates at 40 by 60 mm ($1\frac{5}{8}$ by $2\frac{3}{8}$ inches); indeed the camera was called the Vest Pocket Kodak, often abbreviated to VPK. It became the Vest Pocket Autographic Kodak in 1915 with the addition of the usual hinged door and stylus. The VPK was a tremendous success. Although very well made, it was quite cheap at £1 10s in its standard form with a meniscus lens; with a leather covering and Cooke f6.5 lens, it cost £5 10s. Lazy tongs gave way to baseboard models around 1925. The Model B VPK retained the simple lens; the Series III had better lenses and shutters. Quite delightful were special versions of the Series III, the Vanity Kodaks, with the enamel and leather finished in a range of fashionable colours.

As soon as the VPK was launched, other manufacturers were quick to make cameras using the new size of film. One of the first was a roll-film version of the Newman and Guardia Baby Sibyl. Ansco, in America, made a strut-form camera which was sold in Britain by APM, and Goerz, Contessa-Nettel, Ica and Ernemann all made fine cameras, most of which had anastigmat lenses. When those four companies were combined to form Zeiss Ikon in 1926, the new enterprise launched the Ikonette, which had only a cheap lens and shutter.

The popularity of cameras taking eight pictures on a VPK or 127 film waned in the 1930s following the introduction of the sixteen on 120 system, which gave similar sized negatives at half the price.

Claiming a place in the miniature camera field were stereoscopic cameras taking 45 by 107 mm ($1\frac{3}{4}$ by $4\frac{1}{4}$ inch) plates. The pioneer was the Verascope, made in France by Jules Richard from the mid 1890s. The general construction, which altered little in thirty years, was a slightly tapering metal box, with a viewfinder between the pair of taking lenses. It was usually supplied with a changing box to take a dozen plates; single metal slides and roll-film holders were also available. Only the best lenses were fitted and the quality of construction was of a very high order. Other companies made stereoscopic cameras using the same format, such as the Stereflectoscope by Voigtlander and Cornu's Ontoscope, but the Verascope was probably the most popular.

For many people, the term 'miniature' became a synonym for a camera using 35mm still film. Although the Leica, from 1925, is

often regarded as the first camera to use 35mm film, there were a number on sale earlier. These pioneering efforts, from just before the outbreak of war in 1914, were designed to take a very large number of exposures on a long piece of film without reloading. For example, the Tourist Multiple from America took 750 exposures of the standard cine frame 18 by 24 mm (¾ by 1 inch), a size we would now called half frame. James A. Sinclair and Company, a British company, announced the Centum camera in 1914. As its name suggests it took one hundred pictures. However, during the war cameras designed to be taken on long touring holidays overseas had little appeal and production ceased. Interest in the use of 35mm film did not die, but it was only in the 1920s, with the war long over, and film emulsions much improved, that new models appeared. Ansco in the USA sold, from 1926, a fifty-exposure 18 by 24 mm (¾ by 1 inch) camera called the Memo. It was nothing more than a leather-covered wooden box with a simple anastigmat lens and three-speed shutter. The film was pushed from one light-trapped removable cassette to a second, similar one by two pegs engaging in the sprocket holes. It was quite popular for a while and, indeed, the film-loading system was reused by Agfa, who merged with Ansco in the USA, in a later camera, the Karat, which took a twelve-exposure film giving 24 by 36 mm (1 by 1⅜ inch) pictures.

The Leica, which had been tested in the market place with hand-made prototypes in 1924, was sold from 1925. In contrast to the Memo and other simple 35mm cameras then being offered for sale, the Leica was a masterpiece of precision craftsmanship. It was made by one of the world's most respected makers of fine microscopes and allied optical and scientific equipment. Although, at first, it sold only in small numbers, the high standard of pictures made by its early and skilful devotees began to win over the prejudices of photographers whose experience had taught them that the larger the negative the better the print. The first model had a non-interchangeable f3.5 lens and a focal plane shutter with speeds from one twentieth to one five-hundredth of a second. A detachable rangefinder which slipped into a shoe on top of the camera could be bought for £2. In time, this became the standard size for accessory shoes for all cameras. A very few Leicas were made with Compur shutters at a slightly lower price than the £18 15s for the focal plane model. In 1930 an interchangeable lens model was introduced, but the more significant improvement was the inclusion of a coupled rangefinder, from 1932, in the Leica II. It coupled automatically to wide angle and long focus lenses in addition to the standard 50mm Elmar lens.

Throughout the 1930s, improvements appeared at regular intervals, from the addition of slow speeds from one second in the Leica III, to an extension to one thousandth of a second in the

Leica IIIA. Lenses with apertures up to f1.5 were available as well as all manner of attachments from microscope adaptors to reflex housings. The Leica led the way to the camera systems we see today.

Such pioneering activities naturally spurred on the competitors. One of the earliest alternative precision 35mm cameras was the Peggy, made by Krauss in Germany. Sold from 1931, it was a bellows camera with lazy tong strutting. The Peggy II, introduced in 1933, had a coupled rangefinder. The cameras are rarely seen today and this suggests that sales, in Britain at least, were only modest. Quite the reverse was true of the Contax camera, sold by Zeiss Ikon from 1932, the year in which the Leica II was introduced. From the outset the Contax was rather larger than the Leica and was not available in a model without a coupled rangefinder. It had a metal slatted focal plane shutter and bayonet mounted lenses rather than the screw fitting used in the Leica. The first model, later designated the Contax I, had a black enamel finish. It was joined in 1936 by the chrome-plated Contax II, in which the range and view finders were combined. The Contax was a little more expensive than the Leica. For example, a Contax II cost £50 10s and a Leica IIIB of similar specification £43, each with an f2 lens.

Zeiss Ikon moved one step ahead of Leitz in 1936 with the Contax III. It had a built-in, but non-coupled, photoelectric exposure meter. Zeiss Ikon brought out a number of 35mm cameras in the 1930s. The Super Nettel was a bellows folding camera which used the Contax style metal focal plane shutter. The lens, a Tessar, was fixed but coupled to a rangefinder, similar in principle to the one used in the Super Ikonta. The Tenax took 24mm (1 inch) square pictures. The more expensive Tenax II had interchangeable lenses, a coupled rangefinder and a Compur shutter. The Nettax stayed with the 24 by 36 mm (1 by 1⅜ inch) format and Contax shutter, and it had a limited range of rangefinder-coupled lenses.

Most of the Leica and Zeiss Ikon models were expensive. 35mm photography for the more modest purse was made possible by Kodak's Retina camera from their newly acquired Dr Nagel's works in Stuttgart. Introduced in 1934, the Retina sold for only £10 10s with an excellent f3.5 Xenar lens and Compur shutter. Of folding bellows design, like a scaled-down roll-film folding camera, it was small and easy to carry. It proved to be very popular and went through a whole series of improvements and model changes. The most significant advance was the inclusion of a coupled rangefinder in the Retina II of 1936.

Folding bellows cameras of similar construction were the Dollina and Super Dollina, the Jubillette, the Weltix and Weltini and the Super Baldina. Mentioned earlier was the Karat, by Agfa.

It, too, was a bellows camera but it used criss-cross struts in place of the folding baseboard construction.

There were a few special cameras using 35mm film. Motor-wound cameras are commonplace today but the feature, although used earlier in roll-film cameras, was first included in a 35mm camera in the Robot of 1934. A large knob on top of the camera was given a few turns to tension a spring which then powered the automatic frame advance, as quickly as the taking button could be pressed and released.

Another camera taking the standard 24 by 36 mm (1 by 1⅜ inch) format did not use 35mm film at all. Its makers recommended individual glass plates, each in a stiff paper plateholder; a separate attachment was available for using six-exposure roll films. It was the Compass, designed by an Englishman, Noel Pemberton-Billings, and made in Switzerland by the watch company Le Coultre. No bigger than a cigarette packet, the Compass had a coupled rangefinder, built-in filters, shutter speeds between 4½ seconds and one five-hundredth of a second, an extinction exposure meter and facilities for making panoramic and stereoscopic pictures. It cost £30, a lot of money in the late 1930s, but the Compass was one of the world's most beautifully made cameras. However, it was not very popular, possibly because most people preferred to use a cassette of readily available thirty-six exposure film than individual glass plates which were only to be had from a few specialist dealers.

In the *British Journal Photographic Almanac* of 1938 there was a portent of things to come. At the back of the advertisement pages, a coupled rangefinder camera was offered for sale from a country not then recognised in the west as a supplier of fine photographic goods. The country was Japan, and the camera a Canon.

The interest in small format cameras, following the success of the Leica, led to the development of a number of miniature cameras using roll film. They appeared first in 1930 taking sixteen pictures, each 30 by 40 mm (1¼ by 1½ inches), on 127 roll film. Since roll film was very popular at the time it was possible to buy it from any chemist's shop. With only sixty thousand Leica cameras sold worldwide it is not surprising that supplies of 35mm film were more thinly distributed. The first of the sixteen on 127 cameras was the Kolibri by Zeiss Ikon, who also brought out a tiny box camera of the same format, the Tengor, later called the Baby Box Tengor. In the same year Nagel introduced the Pupille and Mentor the Threefour. Apart from the Tengor, which was a simple box camera, the others were beautifully made precision cameras with top-class lenses like the Tessar and Elmar. The Kolibri was dubbed by some 'the poor man's Leica', perhaps because the lens pulled out, Leica fashion, on a telescopic tube.

However, at £14 with a Tessar lens, it was hardly cheap. Zeiss Ikon went on to bring out a sixteen on 127 Baby Ikonta a couple of years later which followed the folding baseboard style of camera. It was much cheaper, costing only £9 7s 6d with an f3.5 Tessar lens. Similar small folding cameras were the Dolly, Baldi and Westex Miniature.

Criss-cross or separate corner struts were used in the Goldi, the Ysella and the Ensign Double-8. Another cross-strut camera, which sold well, was the Foth Derby. At only £5 5s it was one of the cheapest cameras to have an f3.5 lens and focal plane shutter. Few 30 by 40 mm (1¼ by 1⅝ inch) cameras were made with coupled rangefinders. Curiously, one of them, the Ensign Multex, was the only serious attempt by British industry to make a precision miniature camera before the Second World War. At first glance it looked similar to the Leica, with the lens mounted in a pull-out tube. Although coupled to the rangefinder, the lens was not removable. A single knob advanced the film and wound the focal plane shutter. At a price ranging from £19 10s with a cheap three-element lens to £40 with an f2 Sonnar, it was not competitive with German cameras and was soon discontinued.

Another British camera taking sixteen pictures on 127 film was very well liked. Unusually the negative size of the moulded Bakelite Purma Special camera was 30 by 30 mm (1¼ by 1¼ inches). The shutter was unusual too. It was a rigid thin sheet of steel operating close to the focal plane. It had a central slot, which was adjusted to a wide or narrow gap by a pivoted weight which swung as the camera was turned on its side. Additionally, in one direction, the shutter had to pull the weight with it, which slowed its travel and increased the exposure. Weight-assisted in the opposite direction, it sped across the frame. Speeds of one twenty-fifth, one one-hundred-and-fiftieth and one five-hundredth of a second were available depending upon which way the camera was turned. The lens, an f6.3 Beck Anastigmat, had no provision for altering either focus or aperture. At £2 10s it was excellent value.

In the 1930s there were a number of very small cameras taking special size films. Some were little better than toys, such as the Ulca and Sida; others were well made and capable of good results. Ensign sold their Midget from 1934. It was only 3½ inches (89 mm) long and ¾ inch (19mm) thick when folded. It opened on four struts, much like their pioneering Ensignette twenty-five years earlier. The six-exposure film gave pictures 35 by 45 mm (1⅜ by 1¾ inches), which was surprisingly large from such a small camera. Purchasers had the choice of the Model 33, at 33s, with a fixed focus lens; a focusing f6.3 Ensar lens raised the price of the Model 55 to 55s. For the 1935 Jubilee the Midget was finished in silver rather than its usual black.

Kodak sold their Bantam camera, which took paper-backed unperforated 35mm film. The absence of perforations allowed a negative size of 28 by 40 mm (1⅛ by 1⅝ inches).

There have always been pioneers trying to achieve what was previously thought to be impossible. The Leica was regarded in this way when it was first sold in 1925. Ten years later, 35mm cameras were well accepted, although their users did have to be very careful with exposure and development to get the best out of them. So, by the early 1930s attempts were being made to make cameras even smaller, down to sizes which became known as subminiature. This time the cameras, or most of them, were precision miniatures, unlike the toy-like Ticka of twenty-five years previously. The first of them, the Minifex camera of 1932, used an unperforated 16mm roll film. It looked like a scaled-down rigid-body 35mm camera. The shutter, though it was the smallest Compur made, dwarfed the tiny body. Good quality anastigmat lenses were fitted and reasonable prints up to postcard size were claimed.

The Coronet Midget, made in Britain, was a cheap moulded plastic camera, with an f11 lens, in effect the tiniest of box cameras. It took a six-exposure roll film, again 16mm wide, giving negatives 13 by 18 mm. For a camera costing only 5s 6d the results were not expected to be very good.

The most influential subminiature camera of the 1930s was undoubtably the Minox, which sold from 1937. It originated at Riga, in what was then Latvia, and was designed from first principles, taking nothing from existing cameras. The film was supplied in double-ended cartridges, much like reduced versions of today's 110 and 126 films. However, it was only 9.5mm wide and gave incredibly small 8 by 11 mm negatives. The body looked like a slightly elongated cigarette lighter which was extended, telescope like, to uncover the lens when taking a picture. The film wound on as the cover was closed and opened again. It focused down to 0.2 metres, which was useful for budding spies for copying secret documents in the forthcoming war. The body was made of satin finished stainless steel. Production transferred to Germany after the war. It is a tribute to the brilliance of its designer, Alfred Zapp, that today's Minox looks very much like the original model of forty years ago.

7. How to date an old camera

With access to a library of almanacs, year books, old magazines and catalogues or, perhaps, a set of modern books on old cameras it should be possible to date a vintage piece of photographic equipment. However, the job is much easier if an approximate date can be assigned first since it narrows the search area. Even without any books at all it is often possible to place a camera within a few years of its date of manufacture. To do so takes a little detective work; it is a case of looking for clues and, from them, working towards a likely date of manufacture. At the end of this chapter are lists of dates covering company mergers, the earliest use of certain camera and lens trade names, the first appearance of various features such as the coupled rangefinder and chromium plating and so on. The easiest way of showing how the lists can be used is to work systematically through the process of dating a few cameras.

Plate 32 shows two hand or stand cameras. At first glance they look quite similar, but one is about twenty years older than the other. Each has a metal body, black leather covering, rise and cross front and double extension. The one of the left is a Tenax made by C. P. Goerz and the other is a Maximar by Zeiss-Ikon. Taking the Tenax first, it will be found in list 1 that Goerz were swallowed up in the Zeiss-Ikon merger of 1926. Clearly it is the older camera. The lens panel is held in a cast U-shaped support, which list 3 puts at later than 1905. It has a Compound shutter, which makes it not much later than 1912 when the Compur shutter was introduced. So it is probably around 1910 plus or minus five years or so. The Zeiss-Ikon camera must be after 1926 and the rim-set Compur shutter puts it after 1928. The most likely date is the late 1920s or early 1930s.

Let us now turn to the three roll-film folding cameras shown in plate 16. The large one, on the left, is fitted with a Goerz Dagor lens in a pneumatically controlled Bausch and Lomb Automat shutter. The centre camera, which takes eight on 120 pictures, has a Tessar lens in a dial-set Compur shutter. It is an Icarette by Ica. On the right is another eight on 120 camera, a Super Ikonta by Zeiss-Ikon. Its brightwork is nickel rather than chrome-plated. The Super Ikonta is easy to date. List 5 says the name was first used in 1934 and list 3 that nickel plating started to give way to chrome around the mid 1930s. It looks as though it was made within a year or two of 1935. Ica were absorbed by Zeiss-Ikon in 1926 (list 1), so the Icarette is earlier. The dial-set Compur shutter is post-1912 and the folding wire viewfinder is typical of a post First World War camera. That has narrowed the date to around the early to middle 1920s. The large camera looks older than the

other two but how can we be sure? It cannot be earlier than 1897 (list 3) and the Dagor lens places it after 1904. With an Automat shutter and front lens panel support fabricated from sheet and strip metal, it is unlikely to be much later than 1910.

Some examples are much easier. If a camera takes sixteen pictures on 127 film, that alone shows it was made from 1930 onwards. Dating from the same period are any 35mm cameras with coupled rangefinders.

Those were a few examples with sufficient clues to be able to put a date on them. Mahogany and brass cameras may not be so easy. Some manufacturers made virtually the same design of camera, under the same name, for thirty or forty years. Some examples are Watson's Acme, Thornton Pickard's Triple Imperial and the field pattern of the Sanderson. Clearly it helps to have the manufacturer's or camera name but it is surprising how many well made wooden cameras exist bearing no name at all. Most of them were made in small workshops or factories and supplied to chemist's shops, chain stores or mail order companies who sold them as their own. List 2 gives an indication of the periods during which some well known manufacturers were in operation. It is worth remembering that most polished wooden field cameras date from later than the mid 1880s; their heyday was around 1890 to 1910. As a very rough guide, the earlier cameras, say up to 1900, had dovetailed joints and square-cornered red or maroon bellows. Later cameras, from the early 1900s, had machine-made comb joints and black bellows with chamfered corners.

Beware of lens and shutter names. Lenses were often switched around by previous owners from camera to camera. Thornton Pickard made thousands of their roller blind shutters, which were fitted to dozens of different cameras by other makers.

Since so many Kodak cameras were made, and made very well, they are the ones most frequently found today. To help in putting at least a 'later than' date on a folding roll-film Kodak camera the introduction dates of the various models have been provided in list 6. It is important to get the name absolutely right since so many of them sound alike. For example, a Kodak Junior Camera is quite different from a Pocket Kodak Junior Camera.

LIST 1: COMPANY NAMES

Companies sometimes changed the name under which they traded, for example G. Houghton and Son became Houghtons Limited in 1904. Companies also merged. Sometimes one of the earlier names was retained in the new title; other companies chose to ignore all their previous names when christening their enlarged

concern. In any event these changes help when dating cameras.

Some of the larger companies to have changed their trading name are listed below. Where applicable, the dates in brackets refer to the year in which the original company started business.

Zeiss-Ikon Limited

Traded from 1926 following the merger of a number of German companies: C. P. Goerz (1886); Ica (1909); Ernemann (1889); Contessa-Nettel (1919) [Contessa (1909); Nettel (1909)].

Eastman Kodak Company Limited

The Eastman Kodak Company in the USA (Kodak Limited in the United Kingdom) absorbed a number of American companies.

 1899 Blair Camera Company (1886)
 1895 Boston Camera Manufacturing Company (1890)
 1898 American Camera Company (1895)
 1903 Rochester Optical Company (1883)
 1907 Folmer and Schwing
 1932 Nagel (1928)

In 1926 they sold the Folmer Graflex Corporation.

Ensign and the Houghton-Butcher Manufacturing Company

Trading originally as Claudet and Houghton, by the time dry plates were sold from around 1880 the name had changed to George Houghton and Son. At that time they were suppliers of photographic materials; cameras were added to the line a little later. The name changed again, in 1904, to Houghtons Limited. W. Butcher and Sons ran a pharmacy at Blackheath, London. It is still there today. They started trading on a large scale in photographic goods in the 1890s. By 1902 they transferred their photographic business to larger premises in central London. Many of their cameras were made for them in Germany, and this put them in difficulties when war started in 1914. From the beginning of the war Houghtons and Butchers pooled their manufacturing resources but sold their own designs under their separate names until, in 1925, they merged completely as the Houghton-Butcher Manufacturing Company. Although they retained that name for the production operations, the selling side became Ensign Limited in 1930. Sometimes only the company's initials were stamped or printed on the cameras. These were GH&S, H Ltd, WB&S and HBM. To camera buyers of the time they would have been as familiar as ICI and IBM are today.

APM (Amalgamated Photographic Manufacturers Limited)

In 1921 there was a merger of several long standing British manufacturers of cameras and photographic materials. Amongst

the more important ones were Marion and Company, Paget and Rajar. APM lasted until 1929, when the business split again. The camera making and selling side continued under the trade name of Soho Limited. These changes mean that the well liked Soho Reflex camera was sold by Marion and Company before 1922, by APM between 1922 and 1929 and by Soho Limited from 1929 to 1940 and beyond.

LIST 2: MAHOGANY AND BRASS CAMERAS

These can be hard to date. Sliding box cameras are mostly from before 1870 and wet plate cameras run from 1851 to the early 1880s. The list gives the names of a number of manufacturers of polished wooden cameras with an indication of their more active periods. Most of the dry plate, square and taper bellows folding cameras, designed to be used on a tripod, were made between 1885 and 1915. Some are earlier and some later. Mr Fred Gandolfi of Louis Gandolfi and Sons was still making them in 1980.

Manufacturers of mahogany and brass cameras

manufacturer	*period most active*		
	pre 1880	*1880-1910*	*post 1910*
Adams and Company		*	*
Billcliff, Joshua	*	*	
Bland and Company	*		
Bland and Long	*		
Butcher, W. and Sons		*	*
Chadwick, W. I.		*	
Dallmeyer, J. H.	*	*	
Fallowfield and Company	*	*	
Gandolfi, Louis and Sons		*	*
Hare, George	*	*	
Horne and Thornthwaite	*		
Houghton, George and Sons		*	
Houghtons Limited		*	*
Houghton Butcher Manufacturing Company			*
Knight, George	*		
Lancaster, J.		*	
Lizars, J.		*	
London Stereoscopic Company	*	*	*
Marion and Company	*	*	
Meagher, P.	*	*	
Murray and Heath	*		

manufacturer	period most active		
	pre 1880	1880-1910	post 1910
Negretti and Zambra	*	*	
Ottewill, T.	*		
Park, Henry		*	
Payne and Chapman		*	
Perken, Son and Rayment		*	
Ross	*	*	
Rouch, W. W.	*	*	
Sands Hunter (Hunter and Sands)		*	
Shew, James F.	*	*	
Sinclair, James A.		*	*
Talbot and Eamer		*	
Thornton Pickard Manufacturing Company		*	*
Underwood, E. T.		*	
Watson and Company		*	*

LIST 3: CAMERA BODY FEATURES

The red window
The small red transparent disc in the back of some roll-film cameras, which was used when winding films from one number to the next, came into regular use in 1895. Two red windows in the back first appeared in the Ensign Cupid camera in 1923. All other cameras with this feature date from 1930 or later.

Folding roll-film cameras
The first roll-film folding cameras, using the red window system, came out in 1897.

Plating
Nickel plating: from the late 1890s. Chromium plating: from the mid-1930s. Nickel plating is always shiny and looks slightly yellow compared with chromium plating. A matt or 'satin' finish was often used for chrome plate, sometimes with a polished surface for parts of the metal trim.

Bellows
Red or maroon bellows up to around 1910. Black bellows from around 1900. Square corners commonplace up to around 1900, after which chamfered corners gradually took over. This reduced the dangers of pinholing at the corners.

Autographic feature
On Kodak cameras only, from 1914 to 1933.

Coupled rangefinders

On Autographic Kodak Special cameras only from 1916. All other cameras from about 1930.

Lens panel support

On folding roll-film and hand and stand plate cameras. All wood construction: up to early 1900s. Fabricated strip, rod and sheet metal: 1900 to around 1914. Cast metal U-shaped stirrup: from around 1905.

Self-erecting front

On folding roll-film cameras. Rarely around 1900 to 1915. The early Number 1 Folding Pocket Kodak cameras had lens panels which moved automatically to the taking position when opened. Ernemann were early pioneers of the arrangement. Apart from these it was unusual on cameras before the mid 1920s.

Body shutter release

Introduced on folding roll-film cameras from about 1933.

Folding wire frame viewfinders

Although used much earlier on press plate cameras, the wire frame finder, of the same size as the negative, was only used on folding roll-film and lightweight plate cameras following the First World War.

LIST 4: LENSES AND SHUTTERS

Lenses

Where a camera is fitted with a non-interchangeable lens its name may help to date it. Some well known ones are listed with their dates of introduction:

Aldis anastigmat, 1901	Heliar, 1902
Aviar, 1918	Protar, 1895
Cooke, 1896	Tessar, 1903
Dagor, 1904	Xpres, 1914

The diaphragms or stops used in the earliest lenses were individual metal discs, each with a specific size of circular opening. They were held in place at the front of the lens by a sliding cylinder. An improvement came in 1858 when strips of brass, with circular holes in them, were slipped into a slot, cut in the lens tube, midway between the front and rear components of the lens. Called Waterhouse stops, they were named after their inventor. Iris diaphragms date from around 1890 onwards.

Shutters

Shutters appeared on cameras with the introduction of fast, dry

plates in the 1880s. At first they were crude but by the 1890s they were being mass-produced by specialist companies. The names of shutters and their manufacturers can often help in judging the age of a camera. As with lenses, it is important to check that the shutter was fitted at the time the camera was made; it is not uncommon to find that a lens and shutter have been taken from one camera and fitted to another.

Focal plane shutters were built into cameras from the mid 1890s.

Between-lens blade shutters came into regular use in the 1890s when an American company, Bausch and Lomb, brought out the Unicum shutter. Speeds between one second and one hundredth of a second were controlled by the escape of air from a little piston on the right-hand side of the lens. A similar-looking piston to the left of the lens was attached, by a length of tubing, to a rubber bulb. When it was given a squeeze the piston set off the shutter. Hundreds of thousands of Unicum shutters and shutters of a later improved version, the Automat, were fitted to cameras on both sides of the Atlantic by dozens of different manufacturers.

Pneumatic control of shutter speed was very popular in Victorian and Edwardian times. Some manufacturers, such as Newman and Guardia and J. Sinclair, continued to use it until the Second World War. However, the Unicum and shutters like it, gradually gave way to mechanically controlled shutters. These give a characteristic whirring sound when operating at speeds below a fifth of a second.

Goerz Sector	1896
Automat	1901
Unicum	1897
Compound, first model	1904
Koilos, pneumatic version	1907
Compound, I,B,T settings beneath lens	1907
Compur, dial set	1912
rim set	1928
Compur Rapid	1935

LIST 5: CAMERA NAMES

Some popular cameras with the year in which the name was first used.

Autorange, 1934	Carbine, about 1903
Bessa, 1929	Contax, 1932
Brilliant, 1932	Eclipse, 1885
Brownie, 1900	Ensign, about 1907
Cameo, about 1902	Ensign Selfix, 1933

Ensignette, 1909
Exakta, 1933
Frena, 1892
Goerz Anschutz, 1896
Ikonta, 1929
Karat, 1934
Klito, about 1905
Kodak, 1888
Leica, 1925
Midg, about 1899
Midget, Ensign, 1934
Nettar, 1934

Reflex Korelle, 1933
Retina, 1934
Robot, 1934
Rolleicord, 1933
Rolleiflex, 1928
Sanderson, Field, 1895
Sanderson, Hand or Stand, 1900
Sibyl, 1906
Super Ikonta, 1934
Una, 1907
Xit, 1895

LIST 6: KODAK CAMERAS

Folding Kodak cameras, with the red window system of film registration, started in 1897. New models then appeared at regular intervals for many years. These are listed below. Folding Brownie cameras are not included. In their early days Kodak film sizes were named after the cameras for which they were made. For example the Number 1 Folding Pocket Kodak camera took a film giving twelve exposures, each 2¼ by 3¼ inches (57 by 83 mm). Around 1912 Kodak introduced a three-digit code number for its films. The old and new systems are listed together.

Folding Pocket Kodak cameras

film code	camera	introduction date	image size (inches)
121	No. 0	1902	1⅝ × 2½
120	No. 1	1897	2¼ × 3¼
116	No. 1A	1900	2½ × 4¼
101	No. 2	1899	3¼ × 3¼
130	No. 2C	1916	2⅞ × 4⅞
118	No. 3	1900	3¼ × 4¼
122	No. 3A	1903	3¼ × 5½
123	No. 4	1908	4 × 5
126	No. 4A*	1906	4¼ × 6½

* Folding Kodak, not Folding Pocket Kodak.

Other folding Kodak cameras and their introduction dates
1897 Cartridge Kodak camera
1910 Special Kodak camera
1912 Vest Pocket Kodak camera
1912 Vest Pocket Kodak Special camera

1914 Autographic Kodak camera
1914 Autographic Kodak Special camera
1914 Kodak Junior camera
1914 Autographic Kodak Junior camera
1915 Vest Pocket Autographic Kodak camera
1915 Vest Pocket Autographic Kodak Special camera
1922 Pocket Kodak Series II camera
1925 Vest Pocket Kodak model B camera
1926 Vest Pocket Kodak series III camera
1926 Pocket Kodak Series III camera
1926 Kodak Series III camera
1926 Pocket Kodak Special camera
1926 Pocket Kodak camera
1929 Pocket Kodak Junior camera
1929 Boy Scout and Girl Guide Kodak cameras
1932 Kodak 620 camera and Kodak 616 camera
1935 Kodak Junior 620 camera

Not every model of Kodak camera has been listed. They were made in the USA, Canada, England and Germany; some were exported, others were not. However, most of the Kodak cameras which were on sale in the United Kingdom between 1900 and 1935 can be found in the list.

8. Museums

Although many museums have small displays of cameras the ones listed below have relatively larger displays or house historically important items. It is advisable to check opening arrangements by telephone before planning a special visit.

Barnes Museum of Cinematography
44 Fore Street, St Ives, Cornwall.
A specialist museum with hundreds of exhibits relating to the history of moving pictures and the photographic image.

Buckingham Movie Museum
Printers Mews, Market Hill, Buckingham. Telephone: Buckingham (028 02) 5226.
A museum of cine cameras, projectors and apparatus of the home movie enthusiast, with demonstrations of old films and equipment.

Fenton Photography Museum
Port Erin, Isle of Man.
A recently established museum set up by one of Britain's most knowledgeable collectors. With an imaginative display the whole history of photography and cinemaphotography can be followed

from its origins to the present day. There is a special children's corner and a working coin-in-the-slot 'what the butler saw' machine.

Fox Talbot Museum

Lacock, Wiltshire. Telephone: Lacock (024 973) 459.

Lacock Abbey was the home of William Henry Fox Talbot. It was there, throughout the late 1830s and early 1840s, that he invented the negative/positive system of photography.

The Abbey, now in the care of the National Trust, is open to visitors. A leaflet is available showing the location of many of Fox Talbot's famous photographs. It is fun to recreate them yourself. Following a public appeal, the National Trust converted an early barn, just by the entrance to the Abbey grounds, into the Fox Talbot Museum. Although it covers all the achievements of this remarkable man, photography has pride of place. Space for more modern camera displays is limited but the Curator is adding to the reserve collection by donations. There is a good photographic bookshop in the entrance lobby.

Grandad's Photography Museum

91 East Hill, Colchester. Telephone: Colchester (0206) 64474.

This privately owned museum, close to the castle, is open to the public every day except Monday. A wide range of equipment is shown dating from the 1850s to about 1930. Magic lanterns and stereoscopic equipment rub shoulders with brass and mahogany cameras. You can peep inside an old darkroom, look at early photographs and even have your own 'likeness' done in Victorian or Edwardian dress. The sepia print is back inside five minutes. This imaginative venture deserves all the support it can get.

Kodak Museum

Headstone Drive, Wealdstone, Harrow. Telephone: 01-863 0534.

The largest collection of photographic images, books and equipment in the United Kingdom. Recently completely re-housed, the Kodak Museum is now open to the general public. All aspects of the discovery and development of photography are shown in this wonderful display. Of special interest are the many contributions Kodak have made to the progress of photography. Nearest station: Harrow and Wealdstone (British Rail and London Transport).

Museum of the History of Science

Broad Street, Oxford. Telephone: Oxford (0865) 43997.

In an elegant building are housed superb microscopes, telescopes, sextants, timekeepers and even the earliest equipment used to make penicillin in quantities large enough to be used in

medicine. There are cases of early photographs and some rare cameras and related equipment. Lewis Carroll (the Reverend Charles Dodgson) was a talented amateur photographer and Oxford don as well as author of the 'Alice' books. Some of his equipment is in the display.

National Museum of Photography, Film and Television
Princes View, Bradford. Telephone: Bradford (0274) 727488.

A superb museum which opened in 1983 and shows all aspects of photography from its origins to the present day. You can even try your hand on a panorama of Bradford with a camera obscura.

Newbury Museum
Wharf Street, Newbury. Telephone: Newbury (0635) 42400.

On view is the George Parker History of Photography Collection, which is on long-term loan to the museum. Over fifty cameras are on display ranging from dry plate photography of the late nineteenth century to the present day. Lenses, exposure meters, processing and projection equipment and flash apparatus complete the display.

The Royal Photographic Society's National Centre of Photography
The Octagon, Milsom Street, Bath. Telephone: Bath (0225) 62841.

The Royal Photographic Society has a wealth of historical material in its collection from a superb collection of images, through a library to a splendid range of photographic equipment. This includes some of Fox Talbot's cameras and a Giroux daguerreotype camera.

Royal Scottish Museum
Chambers Street, Edinburgh. Telephone: 031-225 7534.

A large and very interesting museum. The display of cameras is not extensive but includes some of Fox Talbot's original equipment.

Science Museum
Exhibition Road, South Kensington, London SW7. Telephone: 01-589 3456.

One of this splendid museum's newest galleries takes the visitor through the whole range of still and cine photography. A wealth of material is fully but clearly labelled in a circular gallery which surrounds a reconstruction of Beard's daguerreotype studio. A short, wide passageway lined with historic photographs and rare processes leads to a second gallery devoted to moving pictures. A hologram brings the story up to date.

Woodspring Museum
Burlington Street, Weston-super-Mare. Telephone: Weston-super-Mare (0934) 21028.
 About eighty cameras and related photographic equipment are displayed, including some rare items.

Woolstaplers Hall Museum
High Street, Chipping Campden, Gloucestershire. Telephone: Evesham (0386) 840289.
 An extensive collection of cameras occupies one room of this interesting museum.

9. Books

Since the middle 1960s there has been increasing interest in the history of photography. Much has been published using old photographs to show us places and buildings as they used to be; indeed photographic archives are now valuable sources for social historians. Many books are available which trace photography's artistic developments with some excellent monographs on the work of individual photographers. Creative Camera Books, 19 Doughty Street, London WCIN 2PT, issue a catalogue of hundreds of titles. For general reading a few books on the history of photography and photographic images are recommended. But, since this work is all about cameras, most of the books listed below deal with photographic equipment.

 Books about old cameras fall into three categories: general books about the history and development of the camera and related equipment, works on individual manufacturers or reprints of original catalogues, and finally 'camera lists' in which hundreds of cameras are described with brief notes, usually illustrated by a small photograph of each camera.

General reading
The History of Photography. Helmut and Alison Gernsheim. Thames and Hudson, London, 1969. A large, detailed standard work on the subject.
The History of Photography. Beaumont Newhall. Secker and Warburg, London, 1973. Another standard work.
Pioneers of Photography. Aaron Scharf. British Broadcasting Corporation, 1975. Written to accompany a BBC television series. A very readable, simple introduction to early processes and pioneering photographers.

 Brian Coe, Curator of the Kodak Museum, has written a number of very useful books for general reading:

George Eastman and the Early Photographers. Brian Coe. Priory Press Limited, 1973 Half of the ninety-five pages deal with photography up to 1880 and the remainder with George Eastman's many contributions.

The Snapshot Photographer. Brian Coe and Paul Gates. Ash and Grant Limited, 1977. Another slim, large format book, very well illustrated, which takes an affectionate look at a previously rather neglected aspect of photographic history.

Colour Photography. Brian Coe. Ash and Grant Limited, 1978. Over seventy colour plates and even more black and white pictures illustrate the struggles to record images in colour. Colour photography started much earlier than most people realise.

The Birth of Photography. Brian Coe. Ash and Grant Limited, 1976. A most useful account of the pioneers who, independently, invented photographic processes.

For information on photographic images the next three books are recommended:

Victorian Photography — A Collector's Guide. B.E.C. Howarth-Loomes. Ward Lock Limited, 1974.

Victorian and Edwardian Photographs. Margaret F. Harker. Charles Letts and Company Limited, 1975.

The Photograph Collector's Book. Lee D. Witkin and Barbara London. Secker and Warburg, 1979.

History of the camera

Cameras. From Daguerreotypes to Instant Pictures. Brian Coe. Marshall Cavendish Editions, 1978. The most comprehensive book available on the origins and development of the camera. Beautifully illustrated.

A Short History of the Camera. John Wade. Fountain Press, 1979. A well illustrated and very readable account of how cameras developed from their brass and mahogany origins to the electronic age.

Illustrated History of the Camera. Michel Auer. Fountain Press, 1975. A large format book which contains many illustrations and a minimum of text. Good for browsing.

Antique Cameras. R. C. Smith. David and Charles, 1975. The best of the smaller books on cameras of the early period.

Two books written by well known collectors will appeal to budding collectors.

Collecting Old Cameras. Cyril Permutt. Angus and Robertson, 1975.

An Age of Cameras. Edward Holmes. Fountain Press, 1974.

Specific camera manufacturers

Zeiss Ikon Cameras 1926-39. D. B. Tubbs. Hove Camera Foto Books, 1977.

Zauber der Kamera ('Magic of the Camera'). Helmut Nagel. Deutsche Verlags-Anstalt GmbH, Stuttgart, 1977. All in German, but mostly in pictures, the book gives very detailed information about Nagel and German-made Kodak cameras.

Leica: The First Fifty Years. G. Rogliatti. Hove Camera Foto Books, 1977. A definitive history of the Leica camera and its 'system'.

Reprints of original catalogues and manuals can be most useful.

E. & H. T. Anthony & Co. New York. Illustrated Catalogue of Photographic Equipment and Materials 1891. Morgan and Morgan. Available from Argus Books.

Hove Camera Foto Books, 34 Church Road, Hove, East Sussex, offer a range of reprints:
Zeiss Ikon Catalogue 1936.
Leitz General Catalogues for 1931, 1933, 1936, 1955/8 and 1961.
Leitz New York General Catalogue 1939.
Kodak Catalogue 1894.
The Bicycle Kodaks 1897.
Kodak Catalogue 1915.
Lancaster's Catalogue 1888.

Camera lists

Contax (includes other pre-war Zeiss Ikon 35mm cameras), *Leica and Exakta Checklists* are available from Thoroughbred Cameras Limited, 19 The Street, Ashtead, Surrey. They contain a mine of information.

A Century of Cameras (revised edition). Eaton S. Lothrop. Morgan and Morgan, 1982. Detailed information on about 150 cameras dating between 1839 and 1939.

Blue Book. Illustrated Price Guide to Collectable Cameras. First Master Edition. Photographic Memorabilia. 1982. Brief descriptions of around two thousand cameras.

Collection Michel Auer. Michel Auer. Volumes I, II, and III or combined in a single volume. Hundreds of cameras each illustrated by a small photograph with dates and brief descriptions.

Von Daguerre bis Heute ('From Daguerre till Today'). Abring. Volumes I and II. Photographs of hundreds of cameras with brief descriptions, in German.

Historische Kameras 1845-1970. James E. Cornwall, 1979. A well illustrated listing of hundreds of old cameras. German text with a two page English glossary.

La Photographie des Origines a nos Jours. The illustrated catalogue of an exhibition held in Brussels in 1982. 229

historic cameras are shown in excellent photographs. French text.

These illustrated lists are very useful for tracking down dates and makers, particularly of unusual cameras or of equipment which was not exported to Britain.

Books on old cameras can be obtained from the following sources.

Collector's Cameras, PO Box 16, Pinner, Middlesex. Telephone: 01-428 4773.

Hove Camera Foto Books, 34 Church Road, Hove, East Sussex. Telephone: Brighton (0273) 778166.

Lionel Hughes, 64 Needlers End Lane, Balsall Common, Coventry CV7 7AB. Telephone: Berkswell (0676) 33901.

Teamwork, 49 Shelton Street, London WC2. Telephone: 01-240 1929.

Vintage Cameras, 245-256 Kirkdale Corner, London SE26 4NL. Telephone: 01-778 5841.

Most of the larger photographic museums have bookshops.

10. Organisations

The Historical Group of the Royal Photographic Society
Details from the Secretary, Royal Photographic Society, The Octagon, Milsom Street, Bath, Avon, BA1 1DN. The group's interests embrace every aspect of the history of photography. Meetings are held regularly from autumn to spring with winter and summer outings.

Photographic Collector's Club of Great Britain
Details from the membership secretary, c/o 1 Hazelmere Road, St Albans, Hertfordshire, AL4 9RR. This very active club was formed in 1977 and brings together members from all over the United Kingdom (and overseas) who collect cameras and related equipment. Regional meetings are held several times a year; a newsletter is published regularly and selling and swap meetings and postal auctions are popular.

Leica Historical Society
An organisation devoted to the collection, preservation and research of Leica equipment. Honorary Secretary, c/o Greystoke, 8 Driffold, Sutton Coldfield, West Midlands.

The Magic Lantern Society of Great Britain
Details from the Honorary Secretary, c/o Prospect, Nutley, East Sussex. Some photographic collectors also enjoy collecting and projecting old magic lantern slides. The Society holds

regular meetings and publishes an excellent newsletter, *The New Magic Lantern Journal.*

Zeiss Historical Society
An organisation for those interested in collecting and researching Zeiss Ikon equipment. Information from 166 Westcotes Drive, Leicester. Telephone: Leicester (0533) 857771.

Glossary

Autographic: Kodak patented system for writing notes on to film backing paper which subsequently appeared on the negative.

Bellows: Hollow flexible lightproof 'box' of pleated thin leather. Used to minimise weight and size in folding cameras.

Between-lens shutter (diaphragm shutter): A number of pivoted overlapping blades placed between the elements of a lens. Variable spring tension, air escapement or clockwork mechanisms control the period during which the blades swing open for exposure.

Bromide paper: Fast, light-sensitive paper used for making enlargements. Must be handled under a photographic safelight.

Calotype: Negative-on-paper process devised by W. H. Fox Talbot in 1841.

Cartridge film: Early name for paper-backed celluloid roll film.

Cassette: Small metal canister, with light-trapped slot for holding 35mm still film.

Changing box: Holder loaded in a darkroom with several plates with a facility for changing them sequentially. The change between plates was made in normal light.

Collodion: Nitrocellulose dissolved in ether. Forms a thin, flexible, transparent layer on evaporation of the solvent.

Contact print: A positive photograph made by passing light through a negative on to sensitive paper, pressed in contact with it, in a printing frame.

Coupled rangefinder: A rangefinder mechanically or optically linked to the camera lens.

Cross front: Facility for moving the lens sideways from the midpoint of the plate or film. Used for precise control of perspective or, as a rising front, when the camera is used on its side.

Cut film: See *Sheet film.*

Daguerreotype: First publicly announced photographic process. The silver surface of a copper supporting plate was sensitised with iodine, developed over mercury vapour and fixed in strong salt solution, hypo or sodium cyanide solution.

Darkslide: Another name for a plateholder.

Detective camera: Name originally used for a disguised or hidden camera around the early 1880s. The name was subsequently applied to almost any hand-held camera.

Developer: Chemical used to reveal the otherwise invisible or latent image on a photosensitive material after exposure.

Diaphragm: An aperture, of varying size, placed within or before a lens to control exposure.

Direct positive: A photograph made directly without first obtaining a negative. Examples are daguerreotypes and tintypes.

Double darkslide (DDS): Holder for two plates placed back to back.

Dry plate: Sheet of glass with a light-sensitive surface, usually silver bromide in gelatin, which could be stored and used perfectly dry.

Enlargement: A positive print, larger than the original negative made by projecting an enlarged image of it on to sensitised paper.

Enlarger: Apparatus for projecting an enlarged image of a negative on to sensitised paper.

Falling front: See *Rising front.*

Ferrotype: See *Tintype.*

Field camera: Wooden folding plate camera, of relatively light construction, intended for indoor or outdoor use on a tripod.

Film pack: Twelve sheets of flexible, celluloid film, each attached to a strip of paper, held in a light-tight flat pack. After exposure the sheet was drawn to the rear of the pack by pulling its paper tab.

Film pack adaptor (FPA): Metal or wood holder for a film pack which was attached to the camera in place of the plateholder.

Fixer: Chemical for permanently removing the light sensitivity of photographic materials. Usually hypo (sodium thiosulphate) although sodium or potassium cyanide was commonly used for fixing daguerreotypes.

Focal plane shutter: Cloth or metal band running close to the surface of the sensitive material. Exposure time is controlled by altering the width of gap in the band or its traverse speed.

Focus: Adjustment of the distance of a lens to the film or plate surface to give a sharp image.

Focusing hood: Rigid or folding shield surrounding a focusing screen to protect it from extraneous light.

Focusing screen: Ground glass sheet on which the image is focused and composed.

Folding camera: A camera, usually of bellows form, which can be folded for storage and carrying.

Gaslight paper: Light-sensitive paper used for making contact prints. Slow enough to handle in subdued gaslight without

fogging.

Ground glass screen: See *Focusing screen.*

Hand camera: Term given to cameras designed to be held in the hand, rather than on a tripod, when taking pictures.

Iris diaphragm: A continuously variable diaphragm made of several thin overlapping blades.

Lens: The principle photographic forms are:

Petzval portrait lens: combination of lens elements giving a reasonably sharp image at around f4 over a narrow angle of view.

Achromat (meniscus): thin lenses of crown and flint glass cemented together to form a single meniscus lens. Used at f11 and smaller apertures.

Rapid rectilinear: pair of achromatic meniscus lenses mounted in a tube with a central diaphragm. Used at f8 and below. Gives reasonably sharp pictures; definition improves at smaller stops.

Anastigmat: combination of lens elements giving sharp images, essentially free of all distortions. Made with relatively large maximum apertures, originally around f6.3 in the 1890s, widening to f1.5 by 1939.

Light meter: Instrument for measuring light levels and indicating the exposure required.

Magazine camera: Camera, usually box-shaped, containing six or twelve plates which were exposed and changed sequentially.

Miniature cameras: Term originally applied to cameras taking a negative smaller than 6 square inches (39 sq cm) in area. In time came to be used for cameras taking 35mm still film.

Negative: A photographic image where the light parts of the subject are recorded as dark tones and vice versa.

Plate: Originally metal, later a sheet of glass supporting a photo-sensitive layer.

Plateholder: A slim light-tight box, with a removable cover for holding and exposing photographic plates.

Positive: A photographic image where the subject's light and dark tones are correctly recorded.

Print: A photographic positive, usually on paper.

Rangefinder: Optical instrument for measuring distances between the subject and camera.

Reflex cameras: Form of camera in which an image is focused and composed on a ground glass screen up to the moment of exposure. The image in the *single-lens reflex* is reflected on to the screen by a mirror which moves completely out of the light path an instant before the exposure is made. A separate viewing lens, linked to the taking lens, forms the image in the *twin-lens reflex.*

Rising or falling front: A rising front is a facility for lifting the lens vertically above the midpoint of the negative axis. Useful

for recording tall subjects, such as buildings, without the converging verticals which result from tilting the camera. A falling front, where the lens is lowered with respect to the negative, is used in a similar way to record subjects below camera level without distortion.

Roller blind shutter: An opaque blind, with a fixed gap, travelling from one roller to another close to the lens. Exposure time is controlled by altering the traverse speed.

Roll film: Flexible film giving several exposures on a continuous length of material. Originally unbacked and loaded in a darkroom, from 1895 more usually with an opaque numbered paper backing for daylight loading.

Roll-film holder: Lightproof box for holding and winding roll film. Attached to the back of a plate camera in place of a darkslide.

Sheet film (cut film): Stiff sheets of flexible transparent material, originally celluloid, with a photosensitive coating, used in place of glass plates.

Shutter: Device for allowing light to pass through a lens for a predetermined length of time.

Single metal slide (SMS): A holder for one plate. Usually made from black enamelled sheet steel.

Stand: Early name for a tripod or camera support.

Stereoscope: Viewer for stereoscopic photographs.

Stereoscopic camera: Camera for taking a pair of photographs from positions a few inches apart. When viewed in a stereoscope the resulting pictures give an illusion of depth.

Stop: See *Diaphragm.*

Swing or tilting front and back: Facility for altering the angle of the lens board or sensitive material with respect to the camera base. Used for controlling image sharpness and perspective.

Telephoto lens: Lens giving a larger image than a lens of standard focal length at about the same distance from lens to film or plate.

Tintype (ferrotype): Blackened tinplate bearing a positive collodion image. Used by cheap while-you-wait photographers.

Tripod: Three-legged camera support.

Viewfinder: Equipment for showing the limits of the view which the camera will record.

Viewing screen: See *Focusing screen.*

Waterhouse stops: A diaphragm made from a strip of brass, with a round hole cut in it, which was placed in a slot cut in the lens mount. Came in a series of f numbers.

Wet collodion: See *Wet plate.*

Wet plate (wet collodion plate): Glass plate coated on one side with a layer of collodion carrying light-sensitive chemicals. It had to be exposed whilst still wet; when dry it lost its sensitivity.

Index